# A Exploring Art Quilts

## with STUDIO ART QUILT ASSOCIATES, INC.

### *Vol. 2* | Around the World

**STUDIO ART QUILT ASSOCIATES, INC.**

**Managing editor**: Martha Sielman
**Art director**: Deidre Adams
*Art Quilt Quarterly* **editor**: Sandra Sider
*AQQ:* **Artists to Watch contributing editor**: Diane Howell

## ABOUT SAQA

Studio Art Quilt Associates, Inc. (SAQA) is an international nonprofit organization whose mission is to promote the art quilt. Founded in 1989, SAQA now has over 4,000 members worldwide: artists, teachers, collectors, gallery owners, museum curators, and art quilt enthusiasts.

SAQA is dedicated to bringing beautiful, thought-provoking, cutting-edge artwork to venues across the globe. With access to a museum-quality exhibition program, SAQA members challenge the boundaries of art and change perceptions about contemporary fiber art. These exhibitions not only give artists the opportunity to show their work, but also expose the public to the variety and complexity of the art quilt medium.

**SCHIFFER** PUBLISHING

4880 Lower Valley Road · Atglen, PA 19310

**In this issue**

27

44

EXPLORING
Art Quilts
with STUDIO ART QUILT ASSOCIATES, INC.

*On the cover:*
*Jayne Bentley Gaskins. Perspectives*
22 × 18 inches, 2019

*On the back cover:*
*Susie Monday. On the Day You Were Born:*
*The Sun Flared*
40 × 78 inches, 2019

## FEATURED ARTICLES

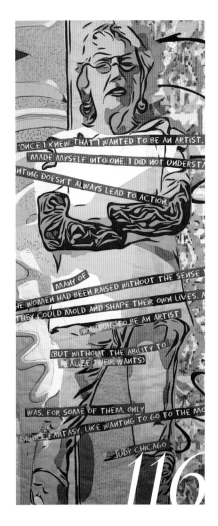

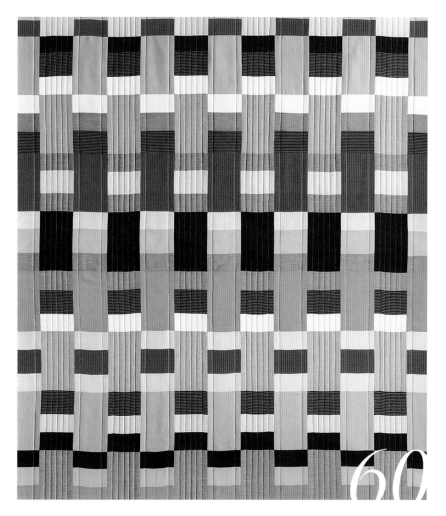

## JURIED GALLERIES

## INTERVIEWS

# Art Quilts Around the World

MARTHA SIELMAN, SAQA EXECUTIVE DIRECTOR

As Executive Director of Studio Art Quilt Associates, Inc. (SAQA), one of my most rewarding experiences is to be able to share art quilts in venues around the world and to showcase the work of artists in so many different countries.

This volume of **Exploring Art Quilts with SAQA, Volume 2: Around the World** is designed to bring you a sampling of the types of art quilts being made today.

*SAQA is dedicated to bringing beautiful, thought-provoking, cutting-edge artwork to viewers across the globe.*

With access to a museum-quality exhibition program, SAQA members challenge the boundaries of art and change perceptions about contemporary fiber art. These exhibitions not only give artists the opportunity to show their work, but also expose the public to the variety and complexity of the art quilt medium.

A wonderful survey of twelve of the exhibitions that SAQA is currently traveling shows the variety and range of types of art being created by SAQA members. Each year, SAQA exhibitions travel to multiple venues in Australia, Canada, China, the Czech Republic, France, Germany, Italy, Japan, Spain, and the UK, as well as in much of the United States. More than a quarter-million viewers get to share what our artists have created each year.

SAQA exhibition themes cover a wide variety of topics, including music, immigration, recycling, nature, and a history of the Art Quilt Movement. SAQA artists often create using just fabric and thread, but many explore unusual materials: window screening, plastic, sewing pattern tissue, and used tea bags. Common techniques include piecing, appliqué, reverse appliqué, whole cloth, paint, image transfers, and embellishments.

This book includes samples of art from twelve current exhibitions. Readers can find the rest of the exhibition images on the SAQA website (www.SAQA.com/art). Two of my favorite exhibitions are **Upcycle!** and **3D Expression** because they both demonstrate the amazing creativity and innovation that artists tap into.

The call for entry for **Upcycle!** challenged SAQA artists to create compelling art without purchasing new materials—to just use things that would otherwise have been discarded. Sherry Davis Kleinman created a traditional-looking quilt by using a variety of layers of damaged window screen—their dog tried to go out their back door when it was closed. Bodil Gardner used recycled clothing and linens to create a portrait of *Mother Earth*. And several artists, including Beth and Trevor Reid of Australia, Sara Bradshaw from the US, and Heidi Drahota of Germany, raided their rag bag of used blue jeans to create wonderful designs in shades of indigo.

More and more SAQA artists have begun experimenting with how to create sculpture out of quilted fabric, so **3D Expression** was proposed as a way to show-case all the varying approaches to how to bring art quilts off the wall and onto the pedestal. Chiaki Dosho's *Coccon 2* uses antique kimono from her native Japan to create a layered silk sculpture that begs to be touched. UK artist Kate Crossley's *Hunter Gatherer; Guardian* uses a jacket form to collect a variety of found objects, including keys, arrowheads, and charms, while *Symbiosis II* by Maria Stoller of Switzerland creates a hanging forest environment showing change through the four seasons.

**Exploring Art Quilts with SAQA, Volume 2: Around the World** also includes in-depth interviews with twelve SAQA artists showing examples of their work, in-formation about how they started working in this medium, and stories of what in-spires them. These artists are drawn together by their love of fabric and thread. Betty Busby demonstrates how she uses her computer to design her surfaces. Linda Colsh explores new three-dimensional forms to attempt to capture the fleeting nature of time. And Patty Kennedy-Zafred pays homage to our ancestors through her use of archival photo image transfers.

Studio Art Quilt Associates, Inc. (SAQA) is an international organization with artists in thirty-nine countries around the world. A series of articles examines art being made in various locales: Norway, South Africa, and Australia and New Zealand are included in this volume. While there are similarities, it's fascinating to see how where an artist lives and the culture that surrounds them influences the art that they make.

About 10 percent of SAQA members go through a rigorous application process to be designated as Juried Artist members. They submit a résumé, an artist state-ment, and a body of work to a review panel made up of existing Juried Artist members. Successful applicants then have their art featured on the SAQA website and in SAQA's *Art Quilt Quarterly* magazine.

For this volume, we are showcasing art by SAQA's Juried Artist members in seven themed galleries. **Surface Design** features art that is based on fabrics the artists have created or modified. While **Power of Nature** shows different depictions of trees, water, birds, mammals, and insects, **Sense of Place** explores the drama of expansive landscapes and dramatic city views. Many artists use their art to express how they feel about current events and the state of the world. View their powerful statements in **Commentary**. We have included the artists' websites so that you can find out more about them and their art.

I hope that you enjoy this exploration of what's being created around the world. Please visit www.SAQA.com for more inspiration and thousands of images of beautiful art!

Betty Busby
Albuquerque, New Mexico,
USA
http://bbusbyarts.com

*Ginger Jar*
63 × 20 × 20 inches | 2013

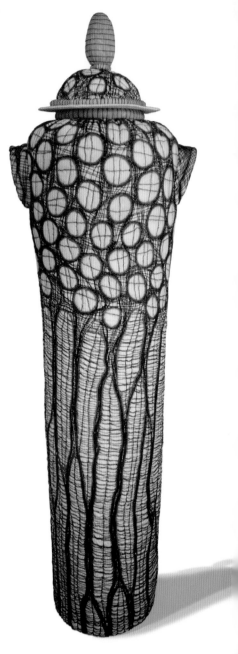

EXHIBITION

# 3D Expression

This cutting-edge exhibition shows how textile art can expand both into the third dimension and into the future. These pieces come off of the gallery walls to hang from the ceiling and stand on the floor, creating an exciting array of 3D sculptures. See art quilts in a whole new way!

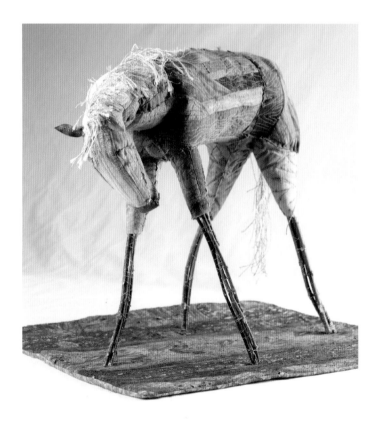

Christina Brown
Portland, Oregon, USA
www.siennatextiles.com/art-quilts

*View from Horseback of Rowena Crest*
16.35 × 17.5 × 14 inches | 2010

Kate Crossley
Abingdon, Oxfordshire, UK
http://katecrossley.com

*Hunter Gatherer: Guardian*
30 × 25 × 14 inches | 2019

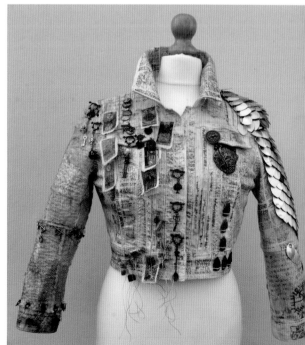

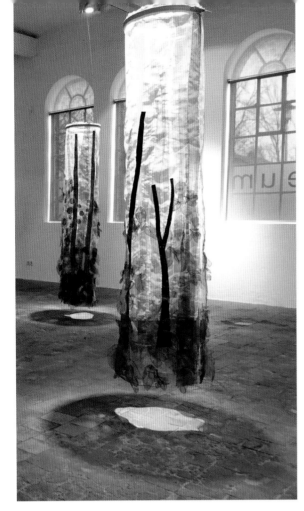

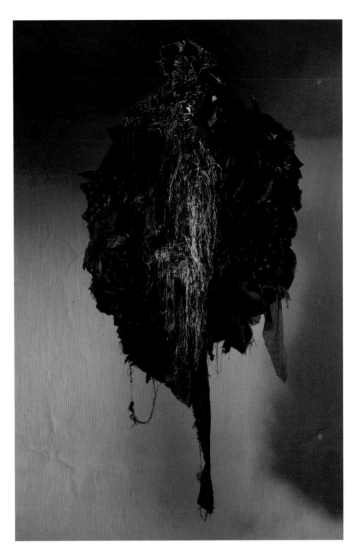

Maria Stoller
Zurich, Switzerland
https://mariastoller.com

*Symbiosis II*
80 × 100 × 100 inches | 2018

Chiaki Dosho
Kawasaki-Shi, Kanagawa-Ken, Japan

*Cocoon 2*
47 × 40 × 6 inches | 2013
Akinori Miyashita

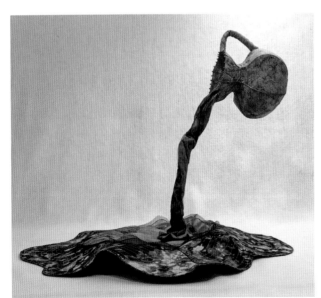

Shannon Dion
Portage, Michigan, USA
https://www.shannondionquilter.com/

*Miriam's Well*
24 × 24.5 × 29.5 inches | 2019

Marie Bergstedt
San Francisco, California,
USA
https://mariebergstedtartist.
com/home.html

*Princess J*
15 × 11 × 11 inches | 2016

# Power of Nature

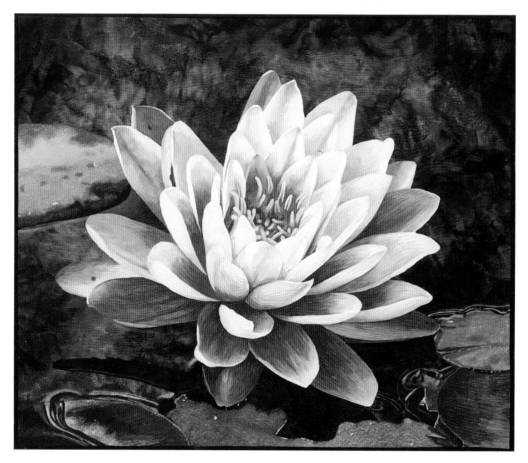

▲ Lenore Crawford
Midland, Michigan, USA
www.lenorecrawford.com

*Water Lily*
*30 × 34 inches (76 × 86 cm)  |  2019*

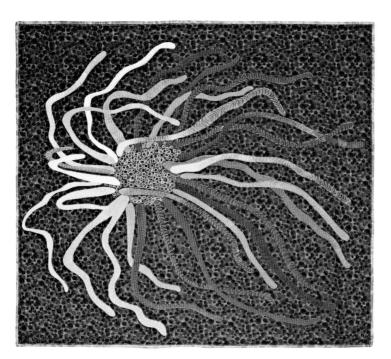

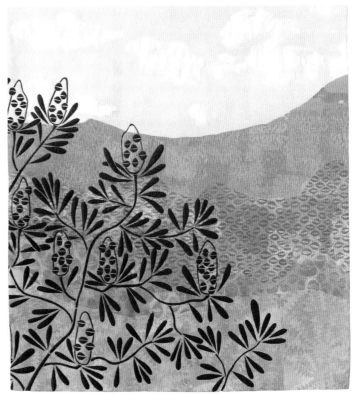

▲ Tracey Lawko
Toronto, Ontario, Canada
www.traceylawko.com

*Honeybee*
*12 × 9 inches (31 × 23 cm)  |  2018*
*Photo by Peter Blaiklock*

▲ Cara Gulati
San Rafael, California, USA
www.caragulati.com

*Sea Anemone Florescence*
*39 × 44 inches (99 × 112 cm)  |  2019*

▶ Susan Roberts Mathews
Ocean Grove, Victoria, Australia

*Banksia Country 2*
*38 × 35 inches (97 × 90 cm)  |  2019*

▲ Phillida Hargreaves
Kingston, Ontario, Canada
phillidahargreaves.ca

*River Eddies*
*15 × 21 inches (38 × 53 cm) | 2017*

▲ Barbara Barrick McKie
Lyme, Connecticut, USA
www.mckieart.com

*Macleays Honey Eater of Australia*
*26 × 26 inches (66 × 66 cm) | 2019*

▲ Hilde Morin
Portland, Oregon, USA
hildemorin.com

*Embracing Moss*
*42 × 37 inches (107 × 94 cm) | 2018*

◄ Alison Muir
Cremorne, New South Wales, Australia
muirandmuir.com.au

*Value*
*39 × 23 inches (100 × 60 cm) | 2019*
*Photo by Andy Payne*

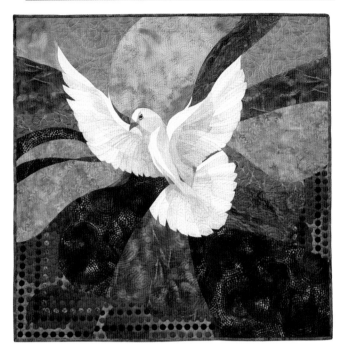

▲ Ruth Powers
Carbondale, Kansas, USA
www.ruthpowersartquilts.com

*Come Holy Spirit*
*35 × 35 inches (89 × 89 cm)  |  2018*

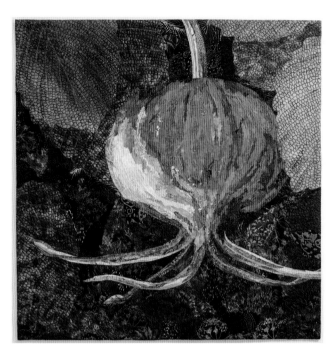

▲ Sarah Ann Smith
Hope, Maine, USA
www.sarahannsmith.com

*Rose Hip*
*36 × 36 inches (91 × 91 cm)  |  2019*

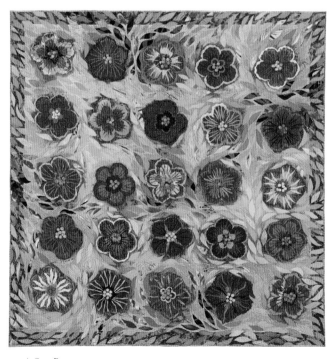

▲ Sue Benner
Dallas, Texas, USA
www.suebenner.com

*Flower Field #5: Variety*
*48 × 47 inches (122 × 119 cm)  |  2017*

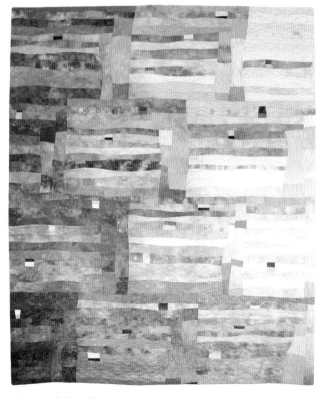

▲ Lynne G. Harrill
Flat Rock, North Carolina, USA
lynneharrill.weebly.com

*Heat Waves XVIII: Coral Reef*
*61 × 51 inches (155 × 130 cm)  |  2017*

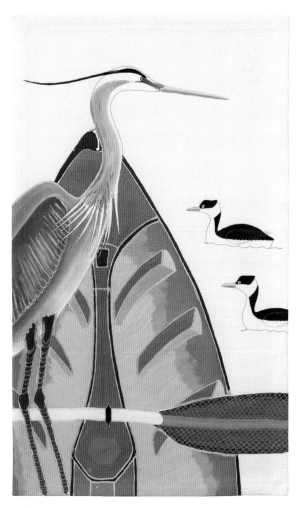

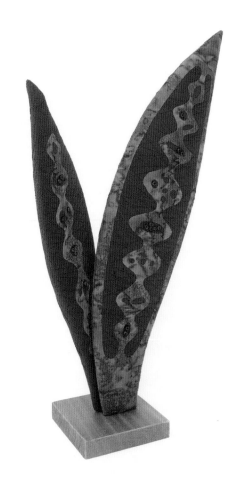

▲ Kathy York
Austin, Texas, USA
www.aquamoonartquilts.blogspot.com

*The Heron, the Kayak, and the Grebes: Part I*
*50 × 30 inches (127 × 76 cm) | 2018*

▲ Susan Heller
Walnut Creek, California, USA
www.quiltedbysusanheller.com

*Seed Pods*
*21 × 9 × 5 inches (53 × 22 × 13 cm) | 2018*
*Photo by Jack Heller*

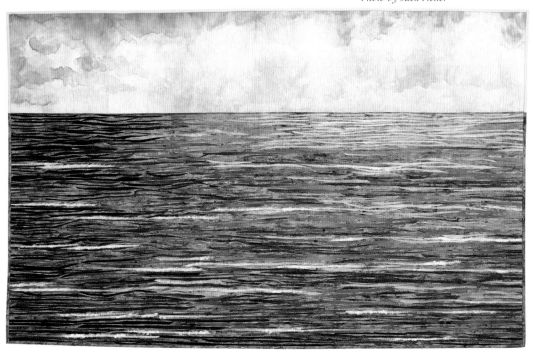

◄ Sarah Lykins Entsminger
Ashburn, Virginia, USA
www.studioatripplingwaters.com

*Morning Rain*
*33 × 53 inches (84 × 135 cm) | 2018*

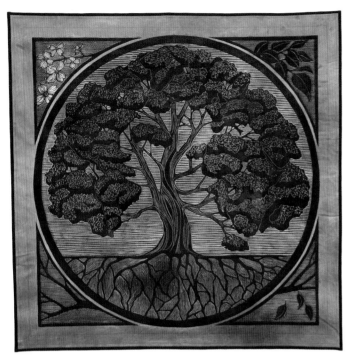

▲ Jill Jensen
Lynchburg, Virginia, USA
www.jilljensenart.com

*Tree of Life*
*37 × 37 inches (94 × 94 cm) | 2019*

▲ Melody Money
Boulder, Colorado, USA
melodymoney.com

*Estuary*
*42 × 28 inches (107 × 71 cm) | 2018*
*Private collection | Photo by Les Keeney*

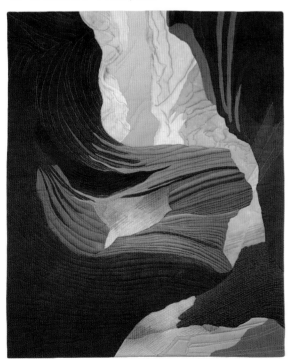

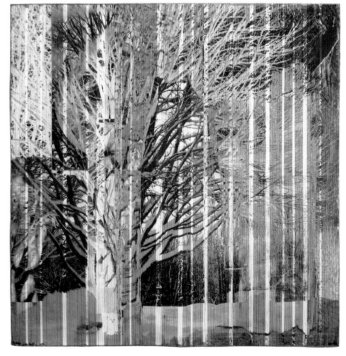

▲ Laura Jaszkowski
Eugene, Oregon, USA
www.joyincloth.blogspot.com

*The Lady in the Wind, Antelope Canyon, Arizona*
*32 × 24 inches (81 × 61 cm) | 2019*

▲ Wen Redmond
Strafford, New Hampshire, USA
www.wenredmond.com

*The Content of the Light*
*40 × 40 inches (102 × 102 cm) | 2017*
*Private collection | Photo by Charley Frieburg*

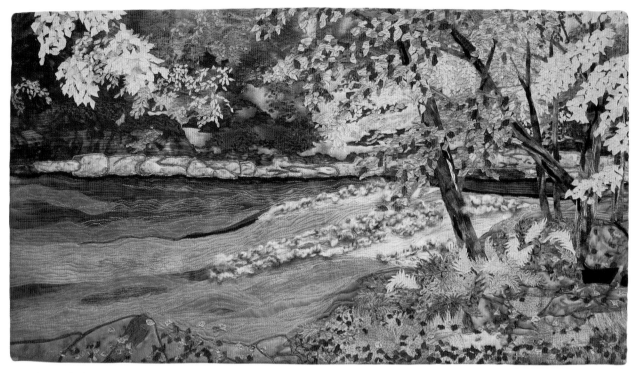

▲ Catherine Ruth Timm
Westmeath, Ontario, Canada
www.catherinetimm.com

*Fall Scene by the Rapids*
*21 × 38 inches (53 × 99 cm)  |  2018*
*Private collection*

◀ Phyllis A. Cullen
Ninole, Hawaii, USA
www.phylliscullenartstudio.com

*The Burning Sea*
*33 × 38 inches (84 × 97 cm)  |  2018*
*Private collection*

▲ Janis Doucette
North Reading, Massachusetts, USA
turtlemoonimpressions.wordpress.com

*Sky Leaves*
*12 × 12 inches (31 × 31 cm)* | *2019*

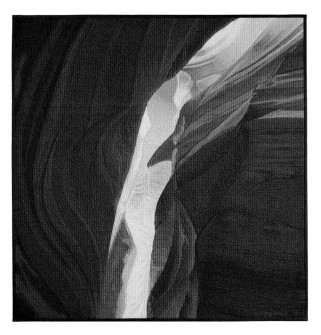

▲ Caryl Bryer Fallert-Gentry
Port Townsend, Washington, USA
www.bryerpatch.com

*Canyon #1*
*30 × 30 inches (76 × 76 cm)* | *2018*

▲ Carole Ann Frocillo
Valencia, California, USA
www.caroleannfrocillo.com

*After The Fire*
*55 × 41 inches (140 × 103 cm)* | *2018*
*Photo by Mark Wallenfang*

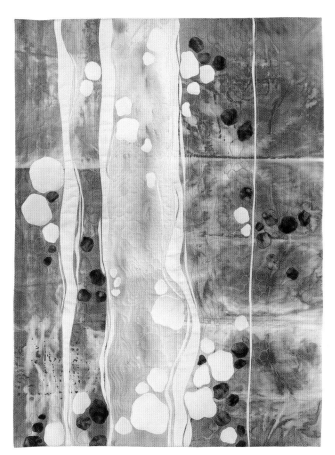

▲ Elisabeth Nacenta de la Croix
Geneva, Switzerland
www.elisabethdelacroix.com

*C'est l'Hiver*
*41 × 31 inches (106 × 79 cm)* | *2018*
*Photo by Olivier Junod*

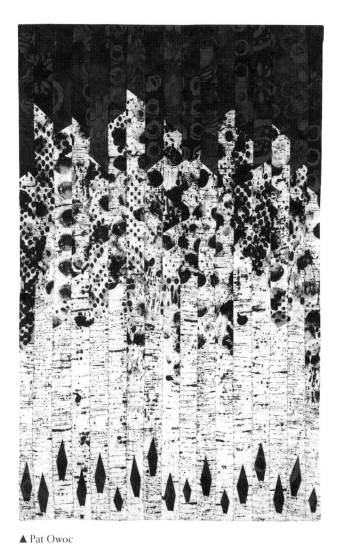

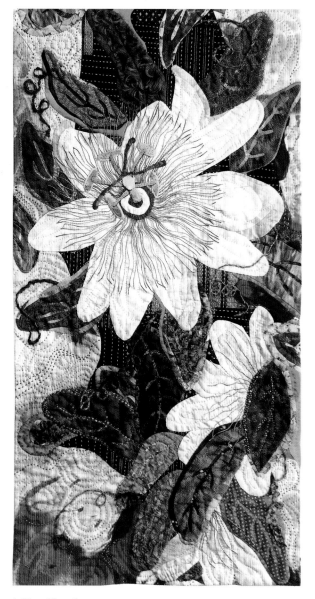

▲ Pat Owoc
Saint Louis, Missouri, USA
www.patowoc.com

*17*
*26 × 16 inches (65 × 41 cm) | 2017*
*Photo by Casey Rae*

▲ Hsin-Chen Lin
Tainan City
www.linhsinchen.idv.tw

*Passion Flower*
*36 × 18 inches (91 × 46 cm) | 2017*

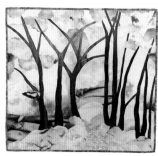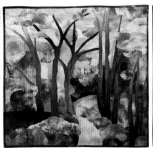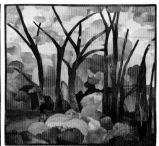

◀ Marjan Kluepfel
Davis, California, USA
www.marjankluepfel.com

*Blue Trees in Winter, Spring and Fall*
*25 × 83 inches (64 × 211 cm) | 2017*
*Private collection*

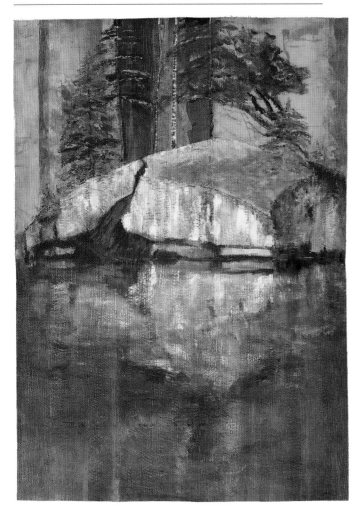

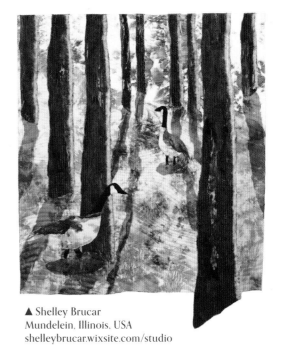

▲ Shelley Brucar
Mundelein, Illinois, USA
shelleybrucar.wixsite.com/studio

*Hide and Seek*
*28 × 25 inches (71 × 64 cm)  |  2019*

▲ Virginia A. Spiegel
Byron, Illinois, USA
www.virginiaspiegel.com

*Boundary Waters 92*
*52 × 37 inches (131 × 93 cm)  |  2018*
*Photo by Deidre Adams*

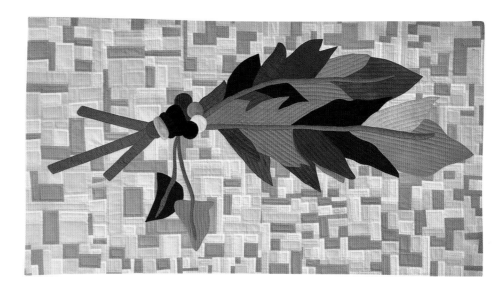

► Tommy Fitzsimmons
Lakewood Ranch, Florida, USA
www.tommysquilts.com

*Wampum*
*31 × 58 inches (79 × 147 cm)  |  2018*

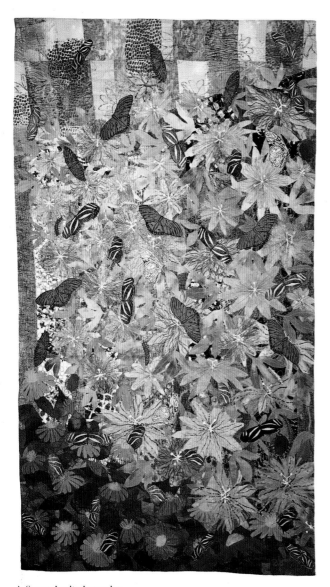

▲ Susan Leslie Lumsden
Brooksville, Florida, USA
www.rebelquilter.com

*Passiflora: Frenzy*
*61 × 35 inches (155 × 88 cm)  |  2019*

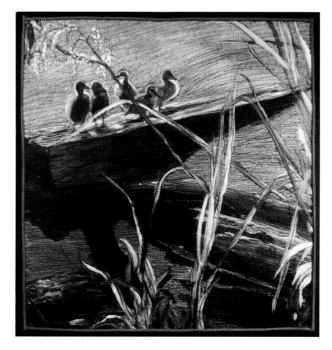

▲ Sue Holdaway-Heys
Ann Arbor, Michigan, USA
www.sueholdawayheys.com

*The Sunbathers*
*12 × 12 inches (31 × 31 cm)  |  2018*
*From an original photo by Sue Benner; used with permission.*

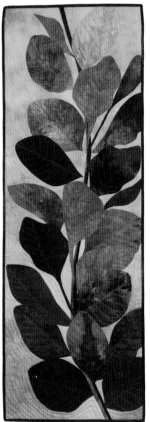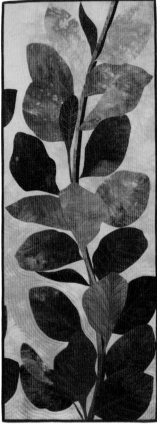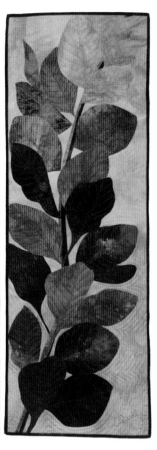

▲ Elaine Quehl
Ottawa, Ontario, Canada
www.elainequehl.com

*Smoke and Mirrors 1*
*40 × 43 inches (102 × 109 cm) | 2018*

◄ Denise Oyama Miller
Fremont, California, USA

*Crayon Box Croton*
*34 × 38 inches (86 × 97 cm) | 2018*
*Photo by Sibila Savage*

◀ Susan Brubaker Knapp
Mooresville, North Carolina, USA
www.bluemoonriver.com

*Drawn to the Light*
50 × 30 inches (127 × 76 cm)  |  2018

▲ Mita Giacomini
Dundas, Ontario, Canada
mitagiacomini.com

*Three Sixty*
30 × 30 inches (76 × 76 cm)  |  2019

▲ Terry Waldron
Anaheim, California, USA
www.terrywaldron.com

*Water Dance*
60 × 25 inches (152 × 64 cm)  |  2014

▲ Priscilla Stultz
Williamsburg, Virginia, USA

*Ancestry tree*
*44 × 38 inches (112 × 97 cm) | 2019*

▲ Barbara J. Schneider
Woodstock, Illinois, USA
www.barbaraschneider-artist.com

*Line Dance, Tree Ring Patterns, var. 13*
*56 × 39 inches (142 × 99 cm) | 2015*
*Private collection*

▶ Sue Sherman
Newmarket, Ontario, Canada
www.sueshermanquilts.com

*Huddle!*
*32 × 49 inches (83 × 126 cm) | 2018*
*Private collection*

# Astrid Hilger Bennett

IOWA CITY, IOWA

## Textile discovery

I did not learn needlework from a female relative, but I had much encouragement from my extended family and neighbors. I thought my lack of drawing skills disqualified me for an art career, so I entered college as a music major. I soon switched to printmaking. In my last semester, I discovered fiber work in a printed and dyed textile class I took to create substrates for etchings.

In 1990, I began to teach fiber art classes in the Home Economics department at the University of Iowa. I refined my printing, painting, and dyeing skills and explored photo emulsion for screen printing. When the department closed in 1991, I refocused my studio practice to include functional and saleable work as well as exhibition pieces.

Since then, I have been juried into *Quilt National* (2004, 2015, 2017, and 2019), *Quilt Nihon*, and many other exhibitions. My work has been included in the *Fiberarts Design Book*.

*Top right:*
*Botanic*
41 × 68 inches, 2018

*Bottom right:*
*LifeCycle - Blue Shirt*
36 × 61 × 1 inches, 2019

## Sensory inspiration

In the last few years, I've been fulfilling a bucket-list promise to draw again. Representational objects, mostly from nature, and landscapes are my visual sources. Since my artwork is made from fabrics on which I paint, print, and create mixed media, I draw on white fabrics and layer them in an abstract manner. Creating fabrics is what drives all other uses. Drawing helps create more depth, and it is meditative.

I often see color in sound. When I work, my finished pieces embrace memory and experience that is not only seen, but heard, smelled, and felt. The texture of an ordinary day, or an exemplary one, can be profound. It's about having one's eyes and ears wide open.

I simply must balance my right/left brain processing through creativity, which is at the forefront of my weekly practice. My ideas for new pieces are generated by playing with fabrics I already have, by drawing or painting, or by challenging my brain to consider new combinations. I'm led to this by a tactile need to work on paper or fabric. Sometimes I am led to start that process by an overwhelming expressionistic urge, an explosion of feelings and sensory impressions that have accumulated inside me. Sometimes I'm lost and reluctant. In that case, drawing helps to jump-start the flow of ideas, as does certain music.

I take a collage approach to my work. There is nothing that cannot be reused in other ways. I will often leave a piece on display for my subconscious to ponder while I actively work on other pieces. Having several pieces going at once allows for freedom to explore. Usually I can resolve the problems. If not, I set the problem pieces aside and give myself permission to tear, cut, stitch, paint, and alter at a future date.

## Life Cycle Series

In June 2019, after a late winter and spring, I chose to collect the fallen flowers in my garden, documenting the accumulating collection daily. Once a week, I photographed them in the context of art pieces, then added them to a master cache. In winter, I used the majority of my flower collection for natural dyes for fabrics on which I can draw. This series ended in early summer 2020, with planting of seeds generated from the flower leavings and a scattering of new flowers. The *Life Cycle* will be complete.

*Left*:
Tarp Series: *Post Japan: Stones*
68 × 75 × 2 inches, 2018

*Right*:
Tarp Series: *Arizona Remnant*
43 × 50 inches, 2018

*Tarp Series: Post Japan: Stones 2*
43 × 87 × 1 inches. 2018

Because the last few years have seen the loss of significant loved ones, this process led me to considering using upcycled clothing as part of the substrate for the *Life Cycle* pieces. John Bennett's shirt was convenient and also a place to record the seasonal changes of plants that he would have noted and consumed. The backdrop for the presentation of these shirt fragments is a screen print made from discarded to-do lists on linen sheets given to me by potter friend.

## Next steps

What remains consistent in more than forty years in textile art is my love for creating fabrics. Their end use varies, with the majority used for my art quilts. To continue to grow, I cannot limit my vantage point. Playing and letting go, and being curious —these are vital traits.

My art trajectory is to create a body of work. It continues even when life intervenes. I invite everyone to join me in the practice of making time for creativity during a weekly studio day, whether it is by learning/contemplation or active doing. Do this for an hour a day, a day a week, or many days every month. Creativity is key to the structure and balance of our lives. It is not a selfish pursuit. It's good self-management to allow you to be meaningfully productive.

Of course, I will continue to make art quilts. I remain taken by the tactile quality of fabrics. I am also focused on encouraging and mentoring younger artists as they take their place in the textile universe.

www.astridhilgerbennett.com

# Aloft

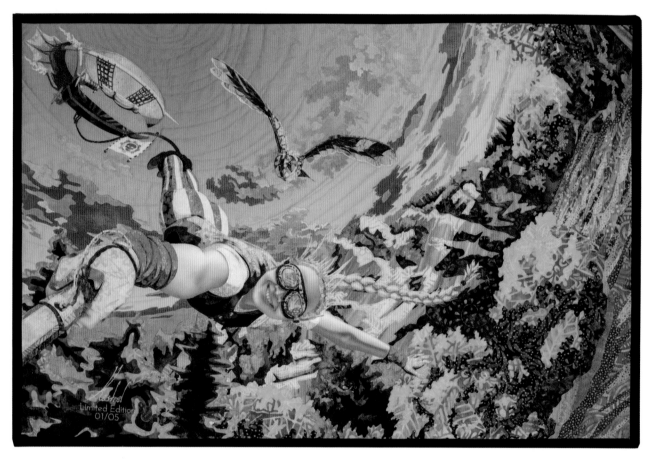

Kestrel Michaud
West Melbourne, Florida, USA
https://kestrelmichaud.com/

*Steampunk Selfie*
24 × 36 inches | 2019

Birds, insects, and even some mammals are able to fly and soar. Plant seeds and kites are carried on the breeze, and the perfect pass can float through the air. Humankind has dreamt of ways to fly, from Icarus's attempt to create his own wings to the advent of airplanes, satellites, and space exploration. This exhibition provides new perspectives through which to see our world.

www.saqa.com/globalexhibitions

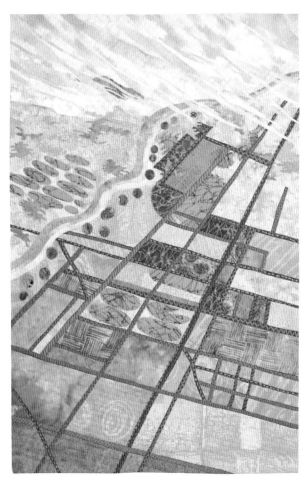

Jan Soules
Elk Grove, California, USA

*Take Off*
50 × 33 inches | 2019

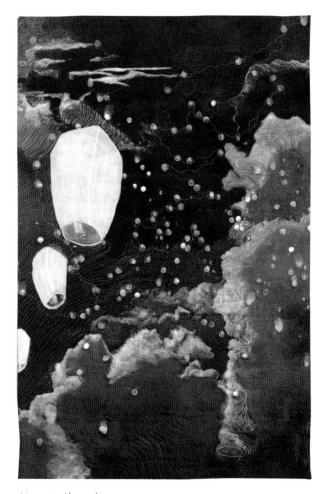

Margaret Abramshe
St George, Utah, USA
https://metaphysicalquilter.com

*Sky Lanterns*
49 × 32 inches | 2019

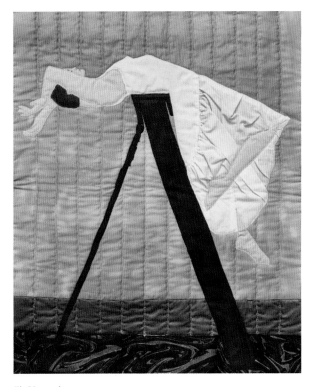

Els Vereycken
Hasselt, Belgium

*Aloft*
34 × 30 inches | 2019

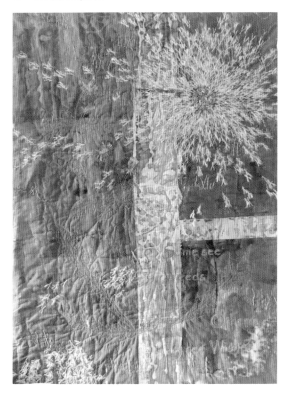

Hildegard Mueller
Lennestadt, Germany

*Dandelion*
47 × 36 inches | 2019

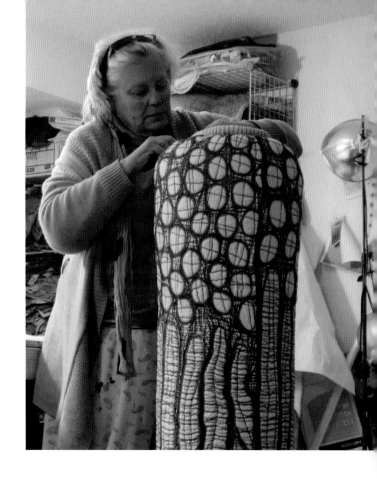

INTERVIEW WITH

# Betty Busby

ALBUQUERQUE, NEW MEXICO

## *Focused efforts*

I didn't become a full-time fiber person until about 2003, and I became aware of Studio Art Quilt Associates (SAQA) at about the same time. I resolved to join as a Juried Artist Member (JAM). The next few years were spent building my resume by making lots of work and entering shows. Following the requirements for applying to become a JAM is a good exercise for most artists, whether professional or not. It helps you focus on the strengths and weaknesses in your work and get organized with a clearer view of what you want to accomplish.

I applied to the Juried Artist program and joined SAQA in 2008. It was a major shift in my career path. Although all my work was original, until that time I had been setting traditional limitations in my mind: work needed to be made of cotton, pieced, and big enough to cover a bed. I found the calls for entry for SAQA exhibitions prescribed works that were considerably smaller. This shift in scale helped me break away from my self-imposed taboos. Also, my gallery representation was then on the East Coast; they also requested smaller works to go into New England homes. At that point, I realized if it didn't need to be a blanket, it could be anything!

Although I experiment constantly, I don't begin a new piece until I complete whichever one is in progress. Finished means that it is ready to hang, labeled, photographed, and put in my database. This allows an on-hand inventory of pieces available for exhibition, sale, and classroom samples.

*Top right:*
*Dark Lichen*
46 × 60 inches, 2017

*Bottom right:*
*Ginger Jar*
63 × 21 inches, 2013

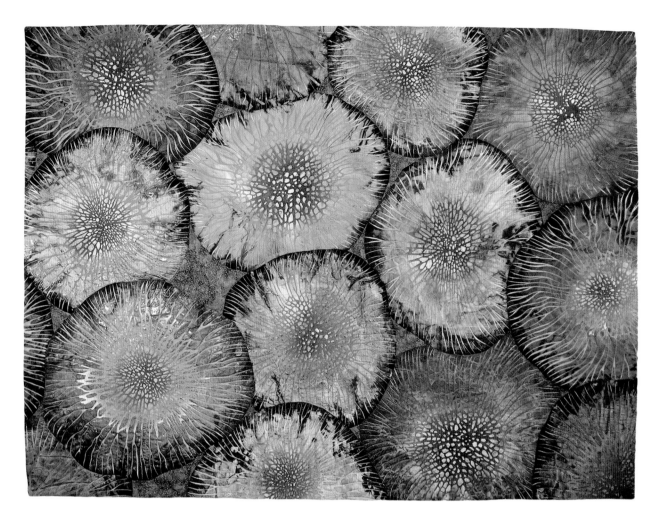

## No such thing as a dead end

If a piece isn't turning out the way I had envisioned, I have a number of weapons in my inventory to help it evolve. In the normal course of things, the stitching phase rarely marks the end of the creation process anyway. There is no problem with any number of additional techniques that can be applied—most of my work has more color and detail added after the stitching, either with paint or multiple types of other art media. This can radically affect the appearance of the work. Other elements can be added, such as couched fibers or appliquéd material.

In short, I don't have very many abandoned projects—textiles are so varied and adaptable that a use can be found for almost all of them!

## Past and future

My fiber sculptural work began about eight years ago as a way to revisit the forms I had loved when I was making ceramics. *Ginger Jar*, a 63-inch-tall reinterpretation of a classic Chinese form, was accepted for SAQA's *3D Expression* exhibition.

Newer work tends to pure abstraction. One of these pieces is *Coloratura*, a series of nine wall-mounted wrapped tubes that will tour with the *Quilt National 2019* exhibition. However, three-dimensional work is an order of magnitude more

*Red River* (detail A)

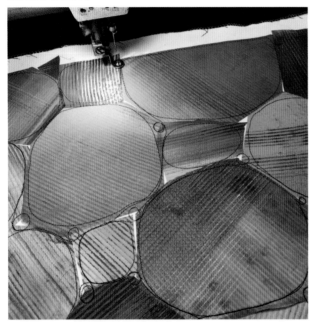

*Red River* (detail C)

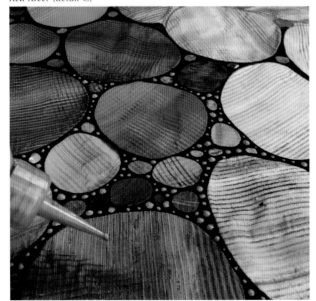

*Red River* (detail D)

*Red River* (detail B)

*Red River*
67 × 58 inches, 2020

difficult to execute than something that hangs on the wall, and shipping costs are punitive. For those reasons, I haven't devoted myself to it full time.

I have a pretty extensive travel schedule. One of the things I do when trapped on an airplane is draw. As an example, I began with one of my designs that was originally made to use as a cutting file for my electric plotter. These files are simply black-and-white line drawings (Red River, detail A), and I can get lots of different effects by putting them through various filters, which sometimes can generate ideas that I want to explore in fabric. I put the black-and-white pattern into a drawing application on my phone and had fun coloring it virtually in the app. I saved several of the results to use as inspiration for a large quilt (Red River, detail B).

I painted silk in a variety of warm and cool colors and used Shiva paint sticks to provide additional texture. I liked the linearity of the paint stick texture contrasted with the roundness of the shapes. I enlarged another, more complex pattern to use as the basis of the full-size design and began slowly filling it in with the painted silk, cutting and fusing each one separately. Each of the shapes was stitched down (Red River, detail C). I used black paint to fill in the lines between the shapes. Because more dots are better, additional colors were added with more paint on top of the black (Red River, detail D).

Creating new work, combined with commissions and an extensive teaching schedule, is what I will focus on for the near future.

# Beyond the Mirror

What do we see when we look in the mirror? Do our images reflect our individual identities, or do we see what we are conditioned to see by society? We need to look beyond the mirror to see our strength of character, intelligence, creativity, skills, and our potential to be even more than what can be reflected.

Artists were invited to lift the veil and look beyond the image seen in the mirror, each creating a new narrative of self-worth that highlights individual attributes over visual image, learning to appreciate who we are and the qualities that make us unique.

Maggie Dillon
Sarasota, Florida, USA
https://www.maggiedillonde-
signs.com

*Poppy Picnic*
42 × 59 inches | 2017

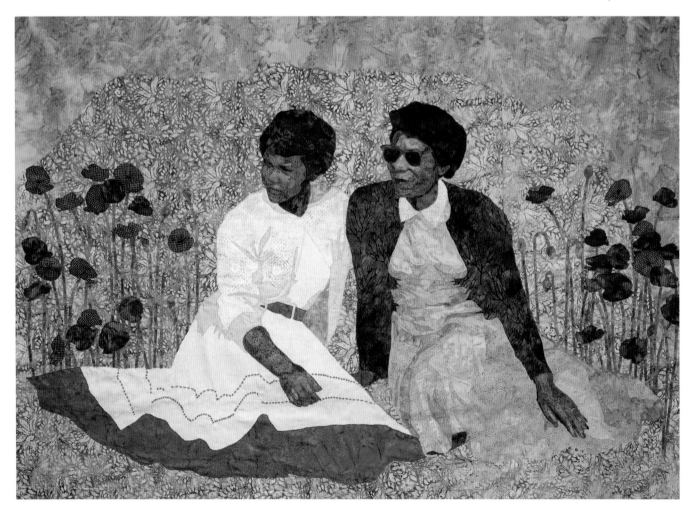

Shannon Conley
Moore, Oklahoma, USA
http://www.shannonconleyartquilts.com

*Peering Out of the Darkness*
50 × 42 inches | 2014

Susan Brubaker Knapp
Chapel Hill, North Carolina, USA
http://bluemoonriver.com

*Purple Girl*
40 × 40 inches | 2017

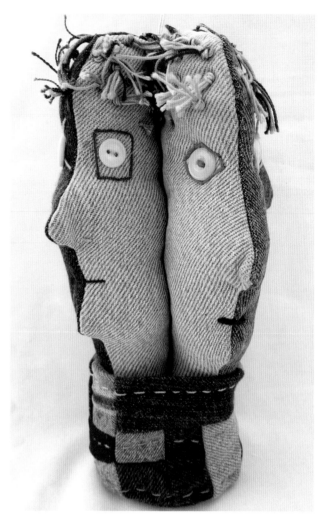

Cathy Perlmutter
South Pasadena, California, USA
http://judaiquilt.com

*Lookouts III: Prickly Personalities*
8.5 × 4.5 inches | 2018

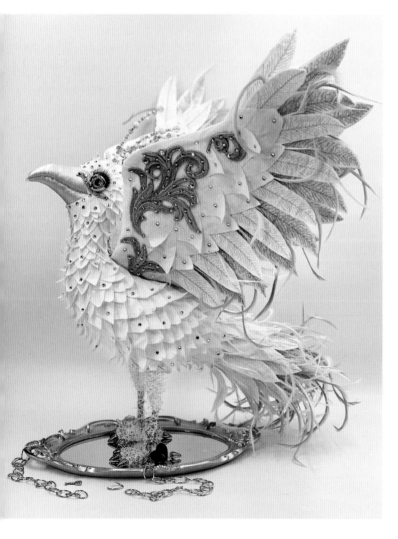

Linda Fjelsted Blust
Reno, Nevada, USA
https://www.wildthingsbylindab.com

*Hope*
24 × 24 × 24 inches | 2020

# Tactile & Textural

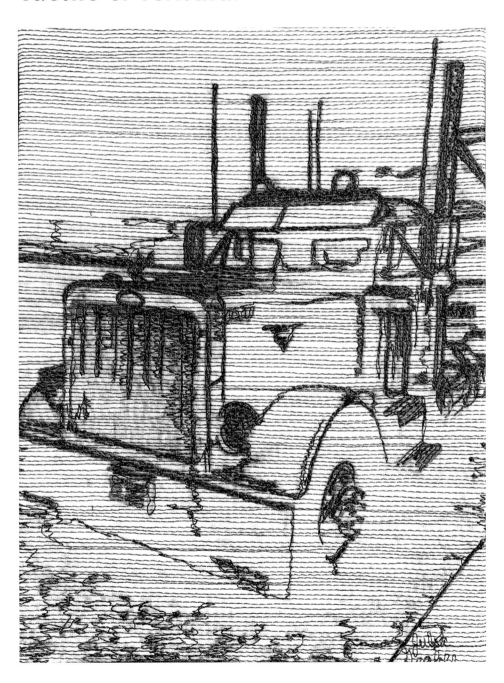

▶ Julia Graber
Brooksville, Mississippi, USA
www.juliagraber.blogspot.com

*The '93 Pete*
*10 × 7 inches (24 × 18 cm)  |  2017*

▲ Lisa Jenni
Redmond, Washington, USA
thinkquilts.com

*Rings of Eternity*
*33 × 41 inches (84 × 104 cm) | 2018*

▲ Linda Filby-Fisher
Overland Park, Kansas, USA
www.lindafilby-fisher.com

*Unity 13, Medicine Wheel series*
*8 × 6 inches (20 × 15 cm) | 2018*

◄ Brigitte Kopp
Kasel-Golzig, Germany
www.brigitte-kopp-textilkunst.eu

*Yin und Yang Bowl II*
*13 × 33 × 33 inches*
*(32 × 85 × 85 cm) | 2018*
*Private collection*

▲ Claire Passmore
Plymouth, Devon, UK
www.clairepassmore.com

*Connectivity II*
*3 × 16 × 16 inches (8 × 41 × 41 cm) | 2019*
*Private collection*

Susan Lenz ▶
Columbia, South Carolina, USA
www.susanlenz.com

*Loss*
*120 × 84 × 84 inches (305 × 213 × 213 cm) | 2018*

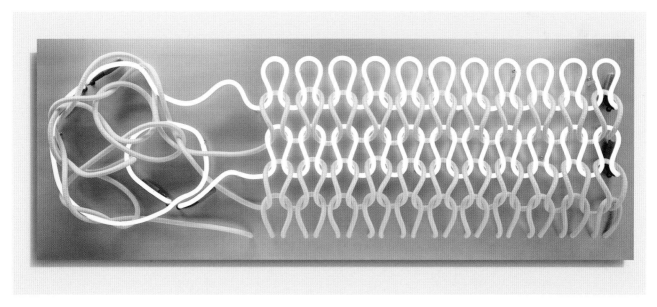

▲ Kevan Lunney
East Brunswick, New Jersey, USA
www.kevanart.com

*Repair*
*24 × 60 × 6 inches (61 × 152 × 15 cm) | 2017*
*Photo by Marsha Schultz*

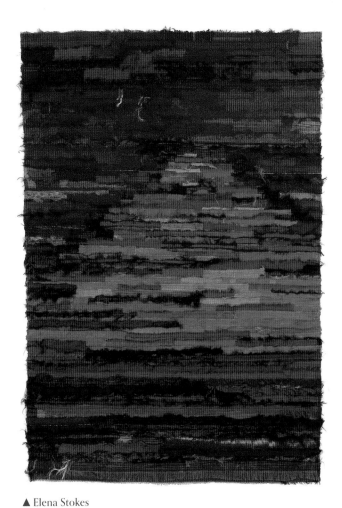

▲ Elena Stokes
Clinton, New Jersey, USA
www.elenastokes.com

*River Dreams*
*60 × 40 inches (152 × 102 cm)  |  2018*

▲ Elizabeth Michellod-Dutheil
Le Châble, Valais, Switzerland
www.elizabeth-michellod-dutheil.ch

*LACUS*
*52 × 33 inches (132 × 85 cm)  |  2018*

◄ Grietje van der Veen
Oberwil, Switzerland
www.textileart.ch

*U-Tubes*
*8 × 31 × 20 inches (21 × 80 × 50 cm)*
*2019*

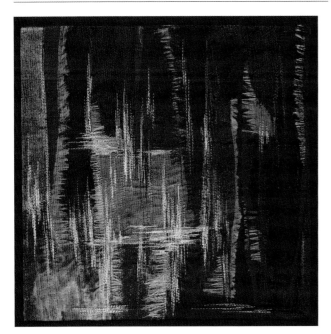

▲ Ludmila Aristova
Brooklyn, New York, USA
www.ludmilaaristova.com

*Etude #47*
*12 × 12 × 1 inches (31 × 31 × 3 cm)*  |  *2017*
*Photo by Jean Vong*

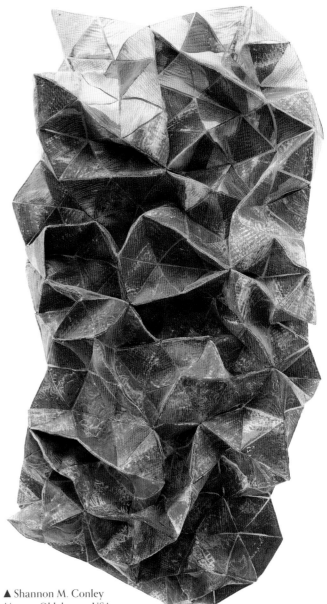

▲ Shannon M. Conley
Moore, Oklahoma, USA
www.shannonconleyartquilts.com

*Tesseract*
*47 × 27 × 4 inches (119 × 69 × 10 cm)*  |  *2018*
*Photo by Mike Cox*

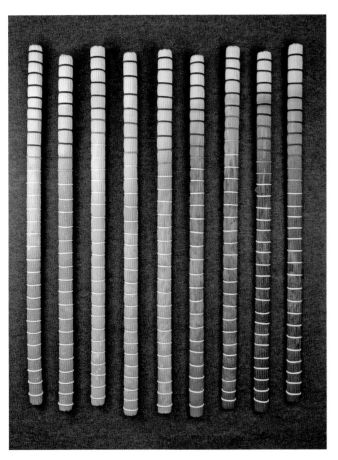

◀ Betty Busby
Albuquerque, New Mexico, USA
bbusbyarts.com

*Coloratura*
*57 × 43 × 6 inches (145 × 109 × 15 cm)*  |  *2018*

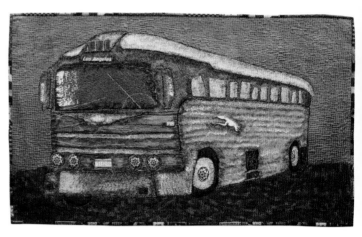

▲ Teresa Shippy
Santa Ana, California, USA
www.teresashippy.com

*1948 Greyhound Bus*
*21 × 34 inches (52 × 86 cm)  |  2017*

◄ Chiaki Dosho
Kawasaki-shi, Kanagawa-ken, Japan
chiakidoshoart.com

*The Crossing Times 13*
*78 × 47 × 1 inches (200 × 120 × 3 cm)  |  2017*
*Private collection  |  Photo by Akinori Miyashita*

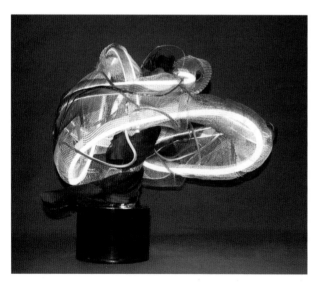

▲ Jayne Bentley Gaskins
Reston, Virginia, USA
www.jaynegaskins.com

*Spiraling Currents of Golden*
*Light*
*13 × 19 × 13 inches*
*(33 × 48 × 33 cm)  |  2019*

Karin Lusnak ▶
Albany, California, USA
www.karinlusnak.com

*Stepping Out*
*26 × 11 × 5 inches*
*(66 × 29 × 11 cm)  |  2019*
*Photo by Sibila Savage*

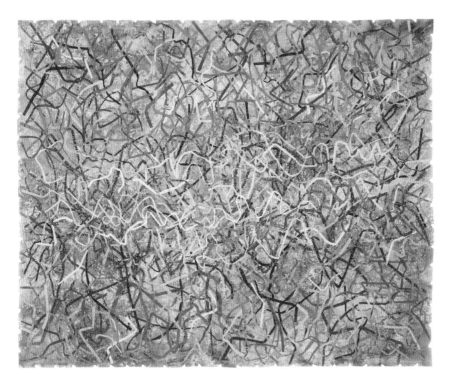

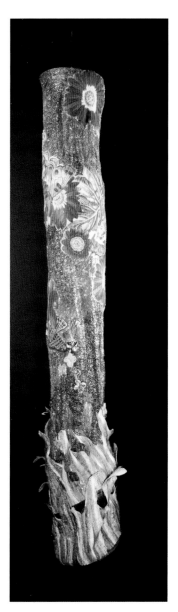

▲ Pat Kroth
Verona, Wisconsin, USA
www.krothfiberart.com

*Fiber Optics*
*44 × 54 inches (112 × 137 cm) | 2017*
*Photo by William Lemke*

▲ Mary Beth Bellah
Charlottesville, Virginia, USA
www.marybethbellah.com

*Garden Twirl*
*75 × 16 × 13 inches (191 × 41 × 33 cm)*
*2019*

◀ Susan Hotchkis
Ross-shire, Scotland
www.suehotchkis.com

*Alderney*
*40 × 41 inches (102 × 104 cm)*
*2018*

▲ Judith Mundwiler
Sissach, Switzerland
www.judithmundwiler.ch

*Network in the Flow of Time*
*19 × 78 × 20 inches (49 × 200 × 50 cm)* | *2017*

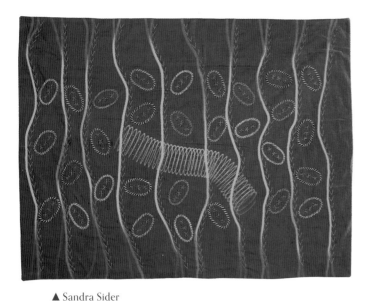

▲ Sandra Sider
Bronx, New York, USA
www.sandrasider.com

*Tunicata IV: Grass Party*
*30 × 40 inches (76 × 100 cm)* | *2019*
*Photo by Deidre Adams*

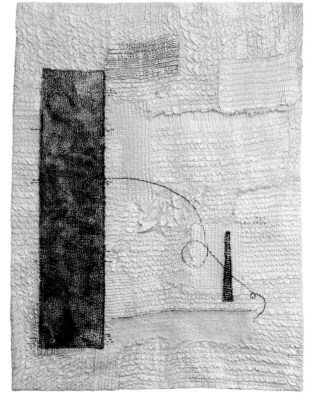

▲ Karen Rips
Thousand Oaks, California, USA
www.karenrips.com

*Background Noise*
*35 × 27 inches (88 × 69 cm)* | *2018*
*Photo by Ted Rips*

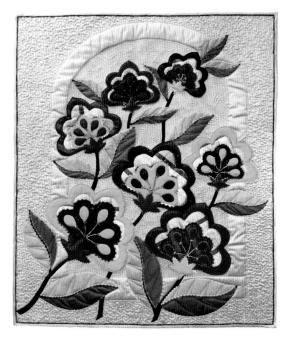

▲ Stephanie Nordlin
Poplar Grove, Illinois, USA

*Jacobean Flowers*
*36 × 30 inches (91 × 76 cm)  |  2017*

▲ Bonnie J. Smith
Port Huneme, California, USA
www.bonniejofiberarts.com

*Water, Water, Everywhere...*
*78 × 63 inches (198 × 160 cm)  |  2017*
*Photo by Spring Mountain Gallery*

▲ Helena Scheffer
Beaconsfield, Quebec, Canada
www.helenascheffer.ca

*Coral Reef*
*36 × 36 inches (91 × 91 cm)  |  2019*
*Photo by Maria Korab-Laskowska*

▲ Marianne R. Williamson
Mountain Brook, Alabama, USA
movinthreads.com

*Blue Cascade*
*35 × 43 inches (89 × 109 cm)  |  2019*
*Photo by Gregory Case photography*

▲ Maryte Collard
Siauliai, Lithuania
www.marytequilts.eu

*Volcano Fissures*
*24 × 24 inches (61 × 61 cm)* | *2019*

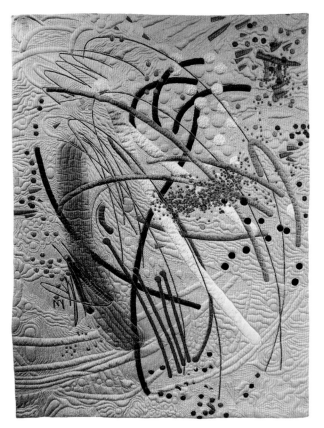

▲ Fenella Davies
Bath, Somerset, UK
www.fenelladavies.com

*Sea Fret*
*59 × 21 inches (152 × 53 cm)* | *2019*

▲ Betty Ann Hahn
Sun City, Arizona, USA
bettyhahnfiberart.blogspot.com

*Quarks*
*50 × 38 inches (127 × 97 cm)* | *2017*

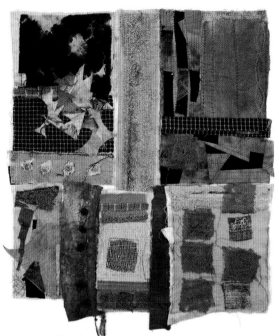

▲ Marilyn Prucka
Monroe, Michigan, USA
www.marilynprucka.com

*Wheat Fields and Water*
*36 × 36 inches (91 × 91 cm)  |  2018*
*Photo by Eric Law*

▲ Kim H. Ritter
Houston, Texas, USA
www.kimritter.com

*Rising*
*72 × 72 × 3 inches (183 × 183 × 8 cm)  |  2019*
*Photo by Bogdan Mihai*

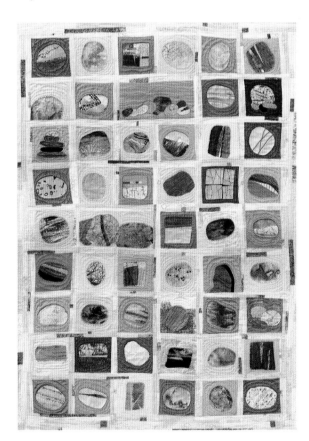

▲ Jean Wells Keenan
Sisters, Oregon, USA
jeanwellsquilts.com

*No Stone Unturned*
*54 × 37 inches (137 × 94 cm)  |  2018*
*Photo by Paige Vitek*

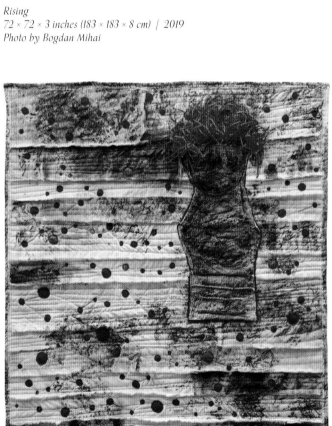

▲ Tiziana Tateo
Vigevano, Pavia, Italy
www.tizianatateo.it

*Idol*
*43 × 40 inches (110 × 103 cm)  |  2018*

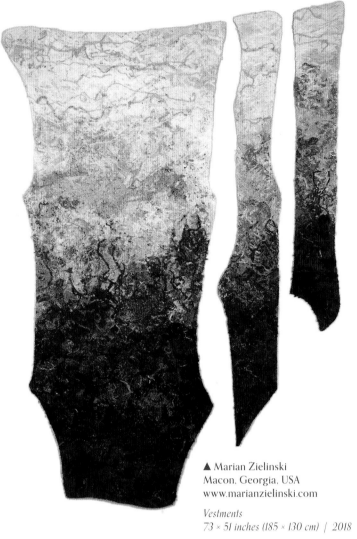

▲ Marian Zielinski
Macon, Georgia, USA
www.marianzielinski.com

*Vestments*
*73 × 51 inches (185 × 130 cm) | 2018*

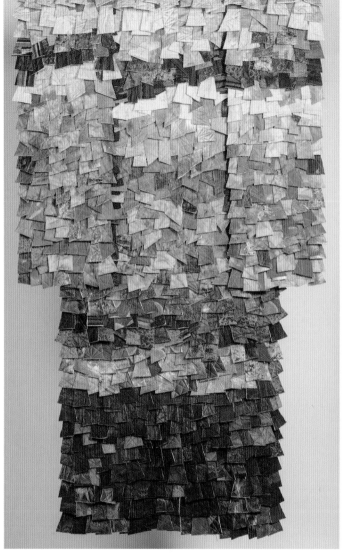

▲ Judith Tomlinson Trager
Portland, Oregon, USA
judithtrager.com

*Sunrise Redwall Canyon*
*68 × 44 × 3 inches (173 × 112 × 8 cm) | 2017*
*Photo by Ken Sanville*

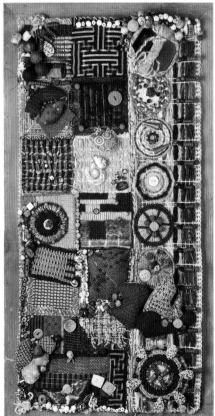

◀ Harriet Cherry Cheney
Dobbs Ferry, New York, USA
www.harrietcheney.com

*Arimatsu*
*30 × 17 × 4 inches (76 × 42 × 9 cm) | 2017*
*Private collection | Photo by George Potanovi Jr.*

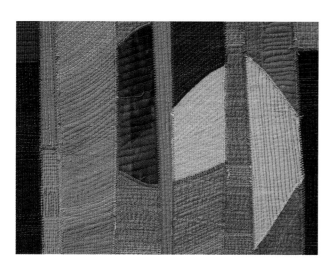

▲ Connie Rohman
Los Angeles, California, USA
www.connierohman.com

*Andante*
*14 × 18 × 1 inches (36 × 46 × 1 cm)* | *2018*

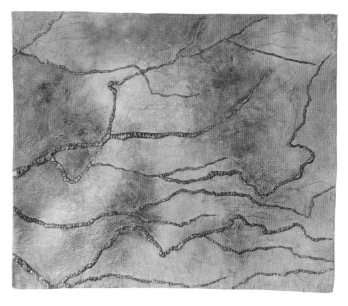

▲ Isabelle Wiessler
Gundelfingen, Germany
www.isabelle-wiessler.de

*Sphere 1*
*42 × 51 inches (107 × 130 cm)* | *2018*

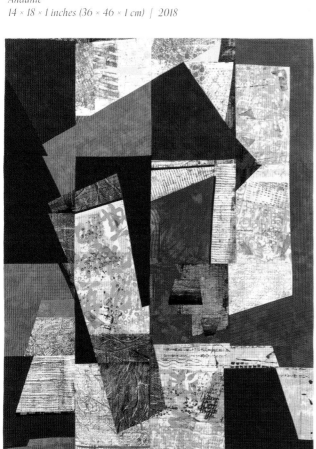

▲ Rosemary Hoffenberg
Wrentham, Massachusetts, USA
www.rosemaryhoffenberg.com

*Still Life*
*60 × 44 inches (152 × 112 cm)* | *2018*
*Photo by Joe Ofria*

▲ Sandra E. Lauterbach
Los Angeles, California, USA
www.sandralauterbach.com

*Jazz Age*
*49 × 42 × 2 inches (125 × 107 × 5 cm)* | *2018*
*Private collection*

▲ Martha E. Ressler
Hamburg, Pennsylvania, USA
www.martharessler.com

*Across the Ages*
*5 × 7 × 1 inches (13 × 18 × 1 cm) | 2018*
*Collection of Greg Sorensen, Wyomissing. PA*
*Photo by Jay Ressler*

▲ Carole Harris
Detroit, Michigan, USA
www.charris-design.com

*Things Ain't What They Used to Be*
*53 × 41 inches (135 × 104 cm) | 2018*
*Mott-Warsh Collection, Flint, Michigan | Photo by Eric Law /*
*ShootMyArt.com*

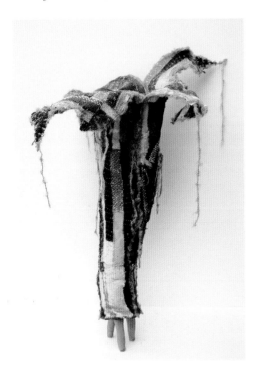

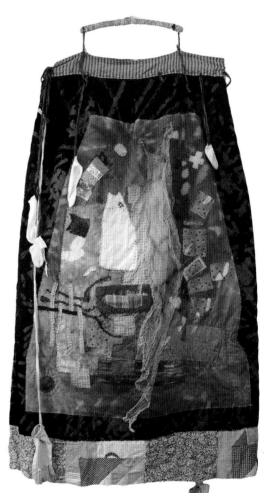

▲ Deborah Kuster
Conway, Arkansas. USA
www.deborahkuster.com

*Thirst*
*28 × 24 × 11 inches (71 × 61 × 28 cm) | 2019*

▲ Lorie McCown
Fredericksburg, Virginia. USA
www.loriemccown.com

*The Story Skirt*
*72 × 42 × 3 inches (183 × 107 × 8 cm) | 2018*

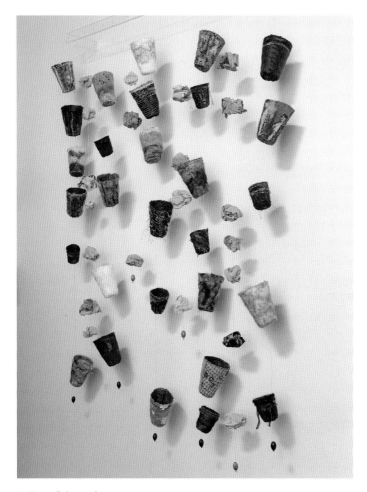

▲ Maya Schonenberger
Miami, Florida, USA
mayaschonenberger.com

*Coffee vs Covfefe*
*56 × 38 × 8 inches (142 × 97 × 20 cm)  |  2018*
*Private collection  |  Photo by Matt Horton*

▲ Diane Gendelman Nuñez
Southfield, Michigan, USA
www.dianenunez.com

*ZigZag*
*72 × 25 × 2 inches (183 × 64 × 4 cm)  |  2018*

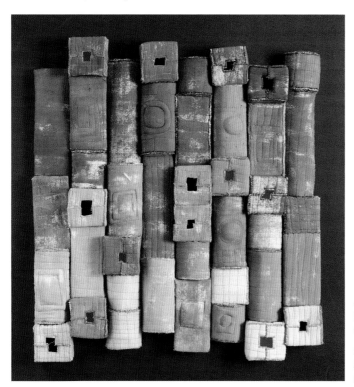

◀ Judy Langille
Kendall Park, New Jersey, USA
www.judylangille.com

*Facade 3*
*27 × 25 × 3 inches (69 × 64 × 8 cm)  |  2018*
*Photo by Peter Jacobs*

## INTERVIEW WITH

# Ana Buzzalino

CALGARY, ALBERTA, CANADA

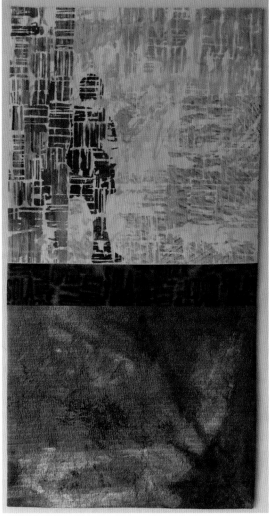

## *The road to art quilts*

I have lived in Argentina and Canada all of my life. As a child in Necochea (a city in Buenos Aires Province), my mother gave me scraps from her sewing. My grandfather, a partner in a Buenos Aires clothing company, gave me leftover cashmere and woolens. After I married, we moved to Calgary, Canada, where I learned to quilt at Freckles Quilt Shop.

For nine years, 1993–2002, we lived as expats in Argentina. It was during that time that I joined a quilting group and took a decorative-painting class. I soon began to merge my two artistic loves.

When we returned to Calgary, I found that other quilt artists were incorporating many different techniques into their work. I started to dye my own fabrics, paint, monoprint, and use screen printing, thermofax printing, deconstructed screen printing—anything that would give me the look I sought. Today, I still experiment and try different techniques, but my traditional roots are evident in my work. I incorporate traditional elements with more-contemporary ones. My latest work also uses hand stitching to add texture and anchor the elements together.

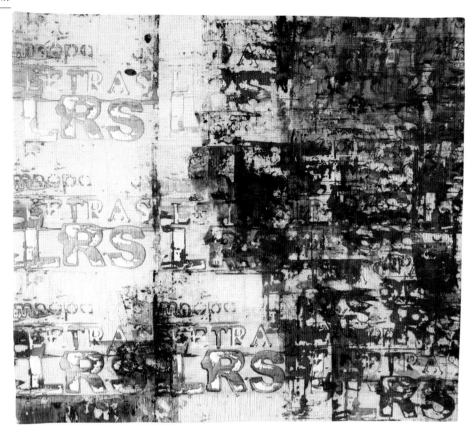

## *Layered inspiration*

Technique is important to me. I rework areas until I'm satisfied with their overall look and the link they create with the viewer. I use varied techniques. Piecing and free-motion machine quilting serve as a base for more layers. The idea is to prepare a background by quilting it tightly to create a "canvas" to which additional surface design techniques can be added.

I like to use words in my work because they are a graphic element and they can communicate a message. Text is sometimes meant to be read, and sometimes it is there as a means of expression. My piece called *What Remains* … is based on memories of growing up in Buenos Aires close to the presidential compound that is surrounded with tall brick walls. Those walls were prime real estate for people to glue posters of all kinds: advertising for sales at supermarkets, upcoming concerts, new books, political candidates, and other information. Layers upon layers of posters accumulated on those walls. Rains came, wind did its job, and the sun bleached them until they peeled, allowing older layers to peek out. Every few months, the government had the walls cleaned, but after a few days, the posters reappeared, perpetuating the cycle.

For the last few years, I have worked on a series based on images of grain elevators. These majestic sentinels of the prairies are disappearing from the landscape. Yet, each one represents the dreams of the people who built it, worked with it, and lived in its vicinity. In the past few years I've gone on photographic journeys in southern Alberta to document and photograph as many of these structures as possible. Northern Alberta will be my next photographic survey.

I want viewers to identify with my art, so I create pieces that are timeless, meaningful, and beautiful—pieces that will evoke enduring thoughts.

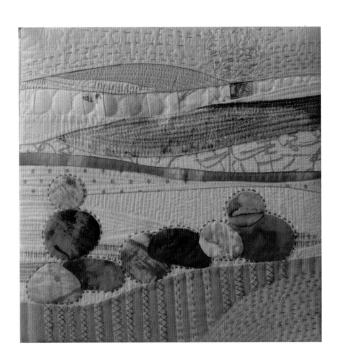

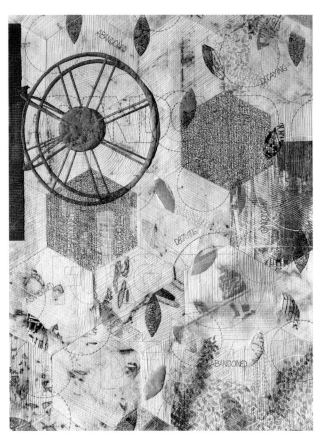

## Building a piece

My process starts with an idea, such as the old wooden grain elevators. I develop that idea and research it. Once the idea is refined, I pull fabrics that could work for the design, using mostly my own hand-dyed and hand-printed fabrics. If I'm piecing, I work on a section at a time, adding and subtracting until I like the configuration; then I sew the pieces together. The finished top is layered and quilted every 1/8 to 1/4 inch to create a flat base. More texture and layers are added.

I find that I enjoy the control offered by starting with whole-cloth backgrounds. Surface design techniques allow me to transform a white piece of fabric with color and imagery. That's quite a departure from the traditional quilting techniques I started with. Also, I now create new fabrics specifically for a piece. Sometimes one piece of fabric will inspire a new direction or a new piece.

I don't finish every piece I start. That's a lesson I learned long ago. If I decide that it's not going the way I originally intended, I park it on the design wall until I understand the problems. Then I can decide whether it is worth pursuing. People usually see finished pieces; art that we are proud of and we exhibit or share in social media. What they don't see are the pieces that do not work—the ones that give us the headaches and keep us awake at night trying to find solutions.

*Left:*
*The rocks we gathered I*
10 × 10 × 3 inches, 2020

*Right:*
*Abandoned*
35 × 26, 2019

## Recent accomplishments

In these times of uncertainty and unprecedented change—and a personal loss—my greatest accomplishment lately has been to keep making and creating. Finding ways to deal with the stress and uncertainty, the constant bombardment of news. As such, I have chosen to read the highlights of the day to keep informed and avoid all the rest—selfishly maybe, but at this time I find that it's necessary to keep myself whole. I want to create, to make things that did not exist before I created them, and to that effect, I choose to show up and do the work. Self-isolation is difficult, but I'm an introvert and like to work in silence, so this fits . . . for now . . . and I'm content.

*The Prairies' Changing Landscape*
26 × 37 inches, 2017

www.anabuzzalino.com

# Connecting Our Natural Worlds

This exhibition showcases artwork that beautifully illustrates the natural wonder of habitats around the globe. Each artist has identified danger to flora and fauna in their own backyard and recommended a call to action that can be taken to help save the species. The artwork will inspire viewers to get closer to nature and become better stewards for our environment.

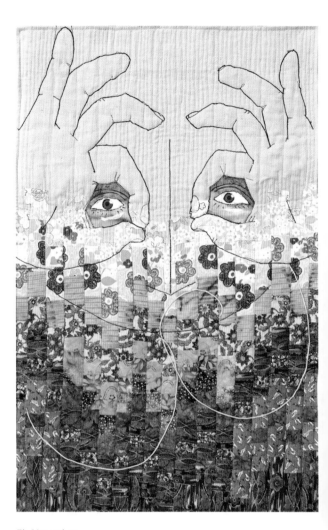

Els Vereycken
Hasselt, Belgium

*Connecting our Natural Worlds*
37 × 24 inches | 2019

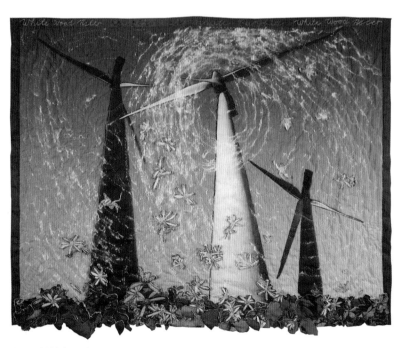

Greta Hildebrand
Fenwick, Ontario, Canada
https://www.ghildebrandartstudio.com

*Turbulence: White Wood Aster (Eurybia divaricate)*
33 × 41 inches | 2019

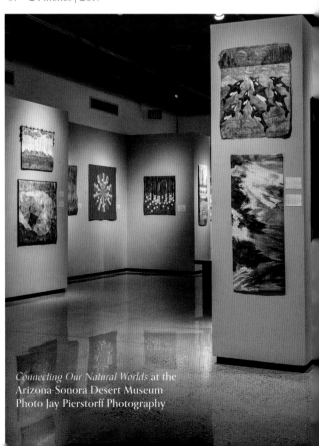

*Connecting Our Natural Worlds* at the
Arizona-Sonora Desert Museum
Photo Jay Pierstorff Photography

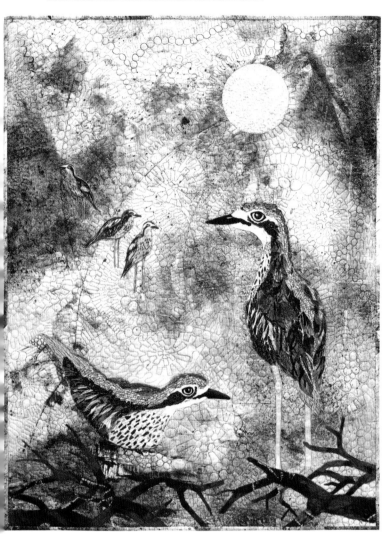

Linden Lancaster
Picola, Victoria, Australia
https://lindenlancaster.com

*Bush Stone-Curlew*
40 × 20 inches | 2018
Photo by Cameron Lancaster

Ruthann Adams
Washington, Utah, USA

*In Awe*
34 × 30 inches | 2018
Photo by Cleary Creative
Photography

# Art Quilts in Australia and New Zealand

BY BRENDA GAEL SMITH

Sandra Champion
*Sea Wall #9*

39 × 66 inches, 2018
*Photo by Bruce Champion*

The corollary of living in the distant Antipodes is that Australians and New Zealanders are outward looking and keenly aware of the wider world. Their artwork often embraces universal themes. While artists also create work that may be informed by local issues or the distinctive natural environment, there is no over-arching design aesthetic for the region. In selecting the works for this article, I decided to showcase the variety of techniques and materials used by Australasian contemporary textile artists.

*Firewheel Spectacular 2* by Lois Parish Evans (New Zealand, formerly Australia) incorporates multiple techniques, including raw-edge appliqué, hand coloring, hand painting, straight-stitch quilting, and free-machine drawing. Lois looks for the extraordinary in the ordinary. Shapes and lines in nature are abstracted and explored in series. Her stylized depiction of the inflorescent firewheel flower plays with positive and negative space and a strong complementary palette.

Alysn Midgelow-Marsden (New Zealand, formerly United Kingdom) works primarily in copper, bronze, brass, and stainless steel combined with fabrics, paints, and threads. The original surfaces are often

Alysn Midgelow-Marsden
*The Space Between viii*

28 × 23 inches, 2017

Lois Parish Evans
*Firewheel Spectacular 2*

40 × 17 inches, 2018

altered by burnishing, texturing, printing, patterning, and patinating. *The Space Between viii* is created in fine stainless-steel cloth, which gives the illusion of fragility and the transparency of organza cloth. Figures are drawn in contrasting wool thread, and patterns are derived from the gaps and spaces created by repeating and reversing the figures.

The folded-fabric creations of Rachaeldaisy (Australia) radiate sheer joy and energy, as exemplified in *Zap Zing Zowie*. This colorful explosion of prairie points is complemented by big-stitch hand quilting in perle thread that adds another layer of texture and color. Rachaeldaisy brings a bohemian flair to her work. While *Zap Zing Zowie* deploys the graphic power of solid-colored fabrics, her other works often include fussy-cut prints, silk, taffeta, silk organza, recycled shirts, hankies, and linen further embellished with doilies, yo-yos, rickrack, and buttons. Look for her new book *Whizz Bang!*

Sandra Champion (Australia) uses paper as textile and has developed techniques to optimize its inherent fragile and often-translucent qualities. She finds inspiration in the Tasmanian landscape, particularly the color of the light interacting with the texture in the natural environment. Her latest series interprets

Rachaeldaisy
*Zap Zing Zowie*

80 × 60 inches

an old sea wall in Secheron Bay close to her home, which has seen many changes since it was built nearly two hundred years ago. *Sea Wall #9* is a modular collage design that incorporates a variety of papers and silks which have been deconstructed, oiled, rusted, burned, painted, and stitched to create a richly encrusted effect that reflect layers of history.

Tara Glastonbury (Australia) is passionate about sustainability and reuse and integrates secondhand waste textiles, scrap, and leftovers in her art. She is drawn to exploring the notions of craft versus art and the politics of craft as women's work. *I would be art* is made from upcycled shirts and is a commentary

on the strong gender bias of the Bauhaus school. Female students were encouraged to pursue weaving rather than painting, sculpture, and architecture.

The monumental fingerprint works of Suzanne Reid (Australia) have garnered two prestigious acquisitive awards: the Golden Textures Award 2019 for *Australian Print* and the Expressions Wool Quilt Prize in 2017 for *Klimt Print #2*.

*Australian Print* honors Australian Aboriginal culture, the oldest-known continuous living culture on the planet. It is a collaboration with Auntie Cynthia at Gallery Kaiela Aboriginal Community Art Shepparton and includes Australian symbols

Suzanne Reid
*Australian Print*

48 × 40 inches, 2018
*Photo by Big Cat Prints*

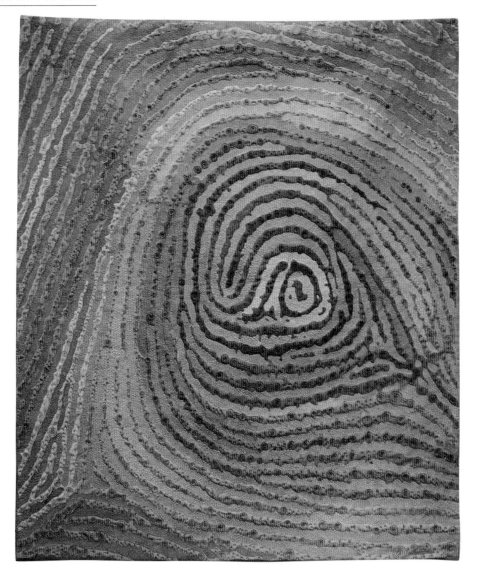

reproduced from original drawings by Troy Firebrace, a Yorta Yorta man. This painted wholecloth is hand and machine-embroidered and quilted. It highlights Australia as a land of contrasts, from the red arid center to the lush green rainforest on the coast.

Graphic design and arts educator Alison Withers (Australia) demonstrates her mastery in a range of piecing, appliqué, and free-machine drawing techniques. A streak of whimsy runs through her portfolio that often belies the serious subject matter. Her latest work, *Women's Magic,* took first prize in the 2019 Australasian Quilt Convention Challenge (Magic) with the striking image of three women with compelling

eyes. Alison observes that, once misconstrued as sorcery, "women's magic" and traditional recipes serve as foundations for modern chemistry and medicine.

The wholecloth foundation of *Place of Reflection,* by Linden Lancaster (Australia), was iced-dyed, with half of the piece hanging out of the bucket so that the sky part would be more muted. Working backwards, Linden designed the trees in mirror image to the water marks and reflections of the lake. The atmospheric scene is enhanced by Inktense pencil work, raw-edge appliqué organza, and stitching. Linden also has work in the current SAQA global exhibition *Season After Season.*

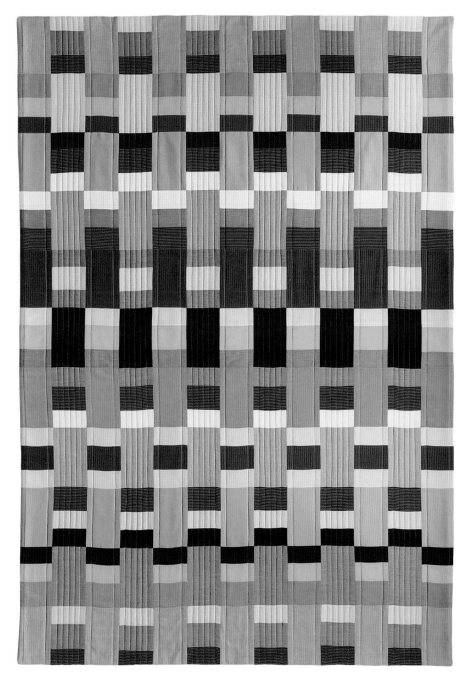

Tara Glastonbury
*I would be art*

55 × 39 inches, 2018

Just as the "number 8 wire" can-do attitude is embedded in the kiwi psyche, Australian and New Zealand artists are resourceful in their use of techniques and materials to communicate their art through the quilt medium.

*Brenda Gael Smith is an artist, independent curator, writer, judge, and mentor. She lives and creates in the "other" Copacabana in Australia and retains a strong connection with her New Zealand homeland. Learn more about Brenda's work in Issue #15 of Art Quilt Quarterly and at www.brendagaelsmith.com.*

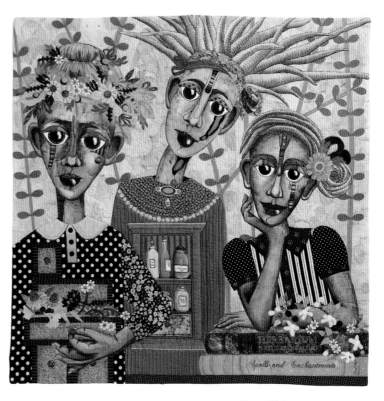

Alison Withers
*Women's Magic*

36 × 36 inches, 2019

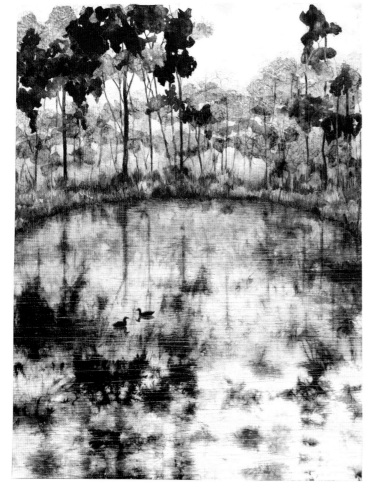

Linden Lancaster
*Place of Reflection*

50 × 36 inches, 2017
*Photo by Cameron Lancaste*

INTERVIEW WITH

# Linda Colsh

MIDDLETOWN, MARYLAND

## *Art quilts discovered*

I was an artist long before I began to sew quilts. My first exposure to art quilts came via the creative quilt artists of central California. Being able to express myself with paint, print, and dye on cloth provided the impetus to push beyond traditional quilts.

A year into making art quilts, I moved to Korea for two years and then to Belgium for nearly twenty-four years. I was on my own artistically, but living overseas exposed me to new cultural inspirations and imprinted my work.

## *Focused imagery*

The subject matter I'm best known for is elderly women and men, many of whom I photographed while living and traveling in Europe. My attention is drawn to the individual who is alone. Street photography depends on becoming invisible to capture images of individuals similarly invisible due to age, gender, height, or generally being ignored. In East Berlin in 2003, I came across a bent old woman in a long coat who slowly walked into my viewfinder. When I got home, I altered her image in Photoshop, recorded thoughts in my workbook, and burned screens to print on cloth. She was the beginning of my figurative work.

I imagined and elaborated the story of a single person with objects: vessels, maps, icons, brooms, and more. To simplify the stories, I stripped away much of the imagery of my early work in favor of presenting an individual in more than one pose, allowing that person to move through space. I incorporated repeating narrow strips I call "zips" to move the eye across the picture plane. I also used

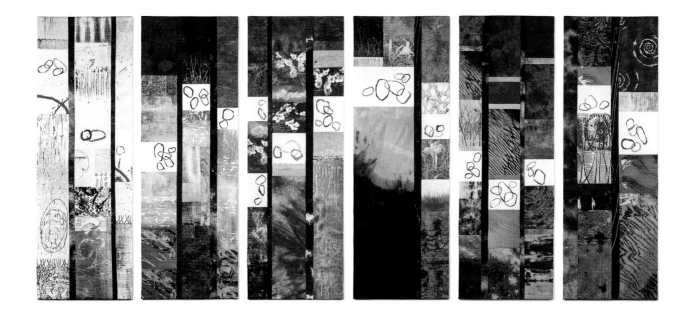

*Hearing the Quiet, Walking the Creeks*
(Six quilts illustrating a year of change)
Each 58 × 20 inches, 2015
*Photos by Ryan Stein Photography*

extremely large-scale brushstrokes or broom strokes to juxtapose the smallness of a single person with the largeness of life.

Along with clothing, my imagery includes chairs and baggage. While living in Asia, a floor-sitting culture, the idea and image of a chair became important. A chair speaks to a place of one's own, a place to rest, to belong, to be. People depicted in my work often carry bags or pull carts, representing a literal load and the burdens of age and emotion. We carry things with us when we move. These portable things are "home."

## A human touch

My style is figurative, but I think of my work as humanist. Whether or not a piece includes figurative imagery, all of my work is about people. For years, individuals dominated my art quilts. Now that I live in the country, I often walk roads without seeing another person. I reflect my aloneness by depopulating my quilts. I employ symbols when literal figures are absent. Creek stones indicate migrating people, and I paint their outlines to represent the hollow places left when they are carried away by the current.

My series Wall Stories references walls and the human-made marks and paint that mark their surfaces. To make a new residence a home, we decorate its walls. I think of the old cupboard where my collection of orthodox icons hangs as my own iconostasis.

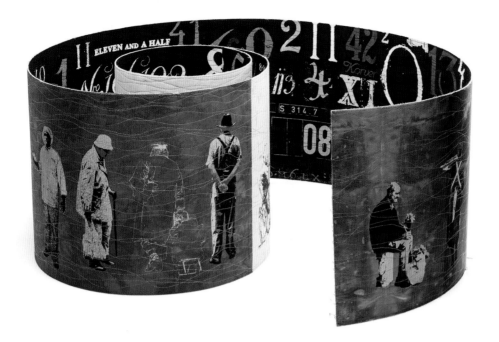

*Once Belonged*
12 × 120 inches (unrolled)
2018
*Photo by Ryan Stein
Photography*

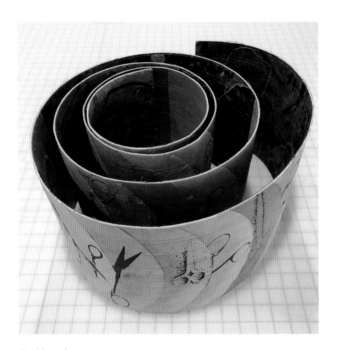

*Par Hasard*
9 × 14 × 14 inches | 2020
*Photo by Ryan Stein
Photography*

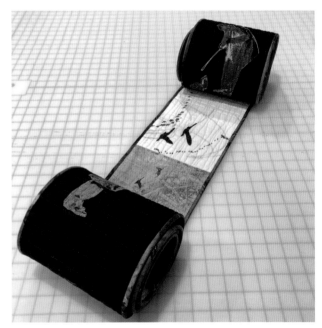

*There Not There*
7 × 12 × 12 inches | 2020
*Photo by Ryan Stein
Photography*

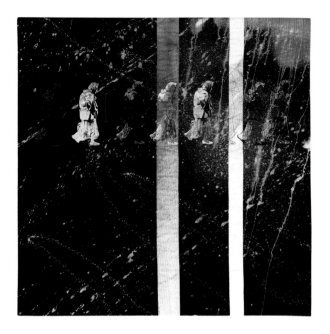
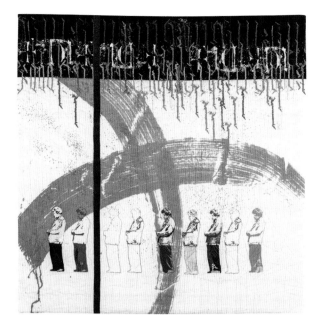

*The Long Run*
40 × 40 inches, 2012
*Photo by Pol Leemans*

*Melancholia*
40 × 40 inches, 2012
*Photo by Pol Leemans*

## Juror and artist

I have been asked to be a juror many times. I find that being on a jury panel pulls me back to the value of simplicity. In the jury room and my studio, I ask: Is a work too complex? Does each visual element contribute to the overall message and impact? Does the quilting support the design or distract from it? When I compare notes with other jurors, we often agree that a detail image is more powerful than the full view. Seeing and selecting work, often different from my own, affirms the value of originality and of owning a unique and personal vision.

## New projects

Along with some in-progress wall-hung art quilts, I am working in some new art quilt forms, including standing scrolls, which are made with very stiff batting. These stand in spirals that reveal only part of the imagery. *Once Belonged* is the first. It uses the conceal/reveal aspect of a coil that reflects my exploration of the presence and absence of migrants. Another recent standing scroll is *Par Hasard,* which is part of a series of wall quilts and scrolls on the subject of chance.

I have also been working with soft scrolls that can also be loose knots or tangles. Like the standing scrolls, only part of the imagery is visible, depending on the form and arrangement of the piece. *There Not There* was the first completed soft scroll / knot. It explores our new, different, and unique situation of coronavirus times.

I continue to be committed to telling stories. My artistic practice includes leaving bits of me in unexpected places. I bury a thimble in the garden, drop a Belgian coin in an American gutter, hide a scrap of cloth between attic rafters, or toss a few buttons in the fields or woods.

I hope my work is like that too—a memory that says, "This artist is leaving you something worth figuring out."

www.lindacolsh.com

# Dusk to Dawn

When the sun dips below the horizon, the world changes: the trees are lit by the silvery light of the moon, and warm lamps glow in a child's room as a bedtime story is read. Owls and bats take to the sky for their evening meals, while other animals curl up safely in their dens.

Dusk to Dawn offers a glimpse of the mysterious world that emerges when darkness arrives. Visitors will be delighted by this collection of nightscapes, animal portraits, and other artistic observations.

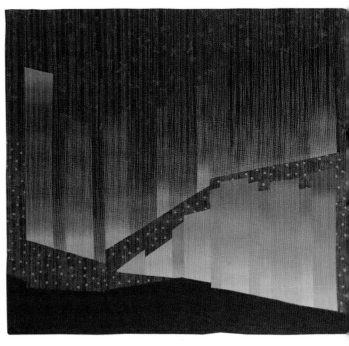

Terry Aske
New Westminster, British Columbia, Canada
http://www.terryaskeartquilts.com/Studio

*Aurora*
29 × 27 inches | 2018

Alicia Merrett
Wells, Somerset, UK
https://www.aliciamerrett.co.uk

*Blue Remembered Hills*
35 × 28 inches | 2018

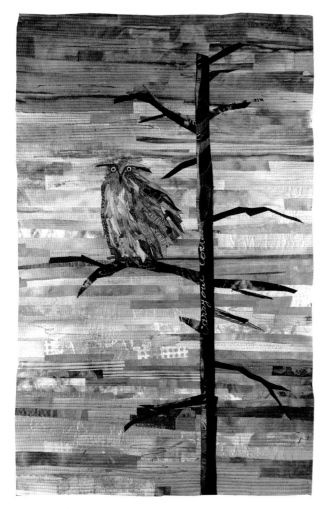

Maya Chaimovich
Ramat Gan, Israel
https://www.mayachaimovich.com

*The World is Dressed in Red*
39 × 39 inches | 2017
Photo by Moti Chaimovich

Pat Baum-Bishop
Shawano, Wisconsin, USA
http://www.patbishop.info

*I See*
48 × 28 inches | 2014

Shin-hee Chin
McPherson, Kansas, USA
https://shinheechin.com

*Moonlight*
36.5 × 40 inches | 2016
Photo by Jim Turner

Gay Lasher
Denver, Colorado, USA
http://gayelasher.com

*In the Hour of Stars*
40 × 24 inches | 2016
Photo by Wes Magyar

# Commentaries

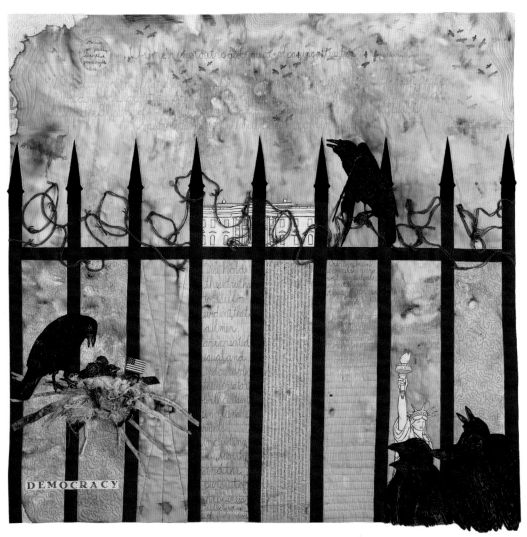

▲ Melani Kane Brewer
Cooper City, Florida, USA
www.melanibrewer.com

*Rise Up: Do Not Go Gentle Into That Good Night*
*39 × 40 × 1 inches (99 × 100 × 3 cm) | 2017*
*Photo by Matt Horton*

▲ Ree Nancarrow
Fairbanks, Alaska, USA

*Habitat Loss, Plumage Mismatch*
*44 × 21 inches (112 × 52 cm)  |  2019*
*Private collection  |  Photo by Eric Nancarrow*

◄ Linda Gass
Los Altos, California, USA
www.lindagass.com

*Where Did the Kings River Go?*
*16 × 16 inches (41 × 41 cm)*
*Private collection  |  2017*

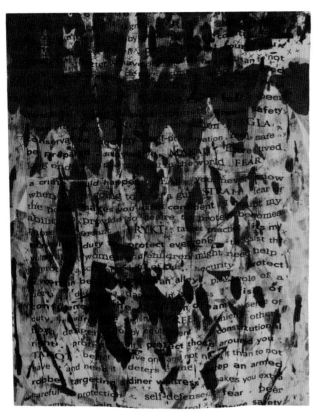

◀ Carol Larson
Petaluma, California, USA
www.live2dye.com

*Culture of Fear*
*52 × 41 inches (132 × 104 cm)  |  2017*

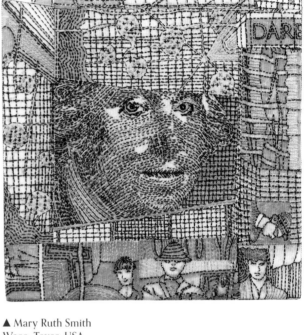

▲ Mary Ruth Smith
Waco, Texas, USA

*Silenced*
*12 × 12 inches (31 × 31 cm)  |  2017*
*Photo by Leah Williams*

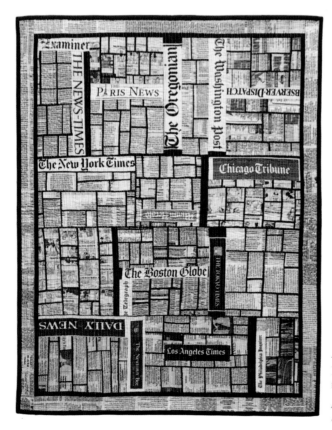

◀ Norma Schlager
Danbury, Connecticut, USA
notesfromnorma.blogspot.com

*All The News That's Fit to Print*
*30 × 24 inches (76 × 61 cm)  |  2017*

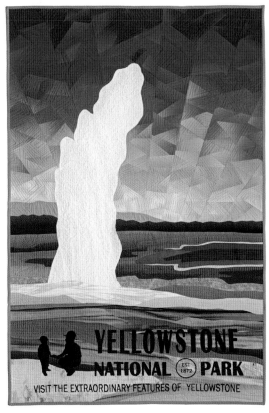

▲ Vicki Conley
Ruidoso Downs, New Mexico, USA
vicki-conley.com

*Preserve to Protect*
*48 × 32 inches (122 × 81 cm)  |  2019*
*Photo by Doug Conley*

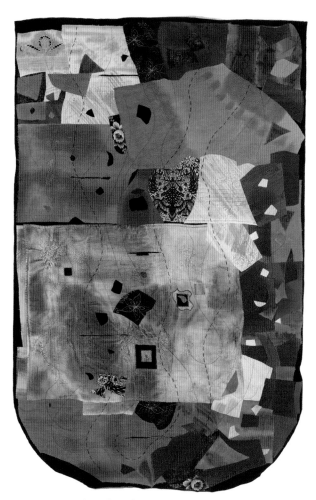

▲ Joan Sowada
Gillette, Wyoming, USA
www.joansowada.com

*Women of Color Rise*
*68 × 43 inches (173 × 109 cm)  |  2019*
*Private collection  |  Photo by Ken Sanville*

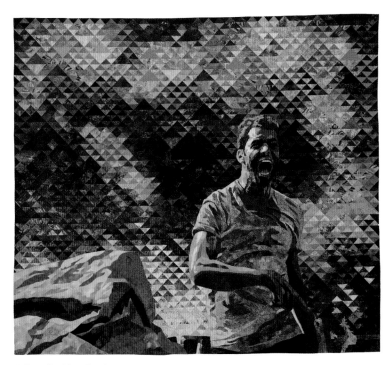

▲ Jennifer May Bowker
Canberra, ACT, Australia
www.jennybowker.com

*After the Last Sky*
*80 × 91 inches (205 × 232 cm)  |  2018*
*Photo by Andrew Sikorski*

▲ Jennifer Conrad
Burnsville, Minnesota, USA
www.designsbyjconrad.com

*Prince UR a Star*
*20 × 20 inches (51 × 51 cm)  |  2018*
*Photo by Jeff Conrad*

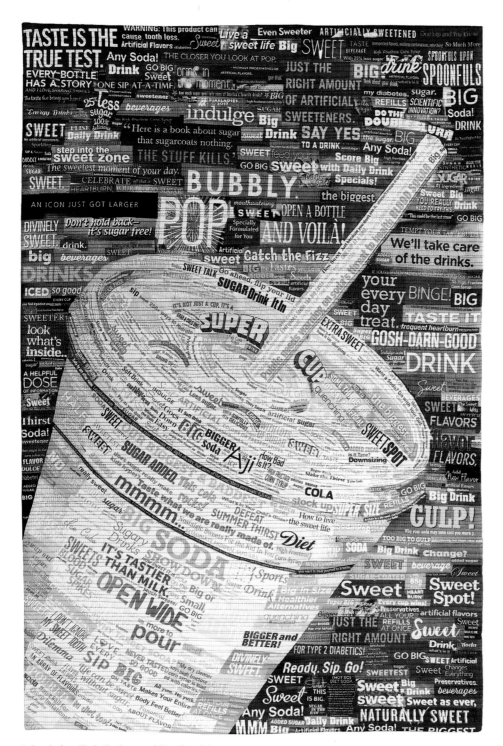

▲ Pixeladies (Deb Cashatt and Kris Sazaki)
Cameron Park, California, USA
www.pixeladies.com

*Super Cup*
*40 × 27 inches (102 × 69 cm) | 2019*

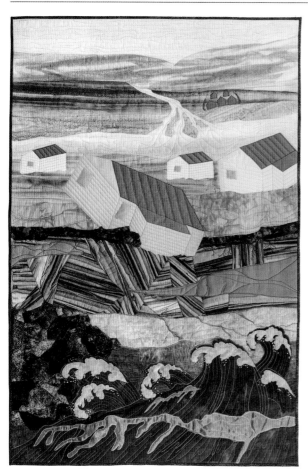

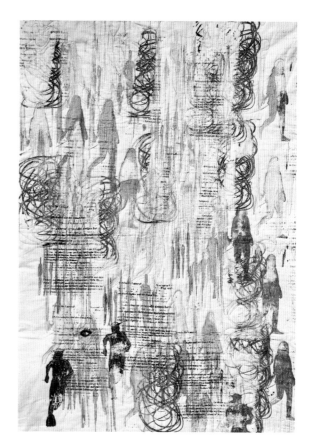

▲ Charlotte Bird
San Diego, California, USA
www.birdworks-fiberarts.com

*Goodbye My Village*
*48 × 32 inches (122 × 81 cm)  |  2018*
*Photo by Gary Conaughton*

▲ Regula Affolter
Oekingen, Solothurn, Switzerland
www.regaffolter.ch

*Flucht 21/2018 Serie Crossing*
*53 × 36 inches (135 × 91 cm)  |  2018*
*Berger Family  |  Photo by JEA*

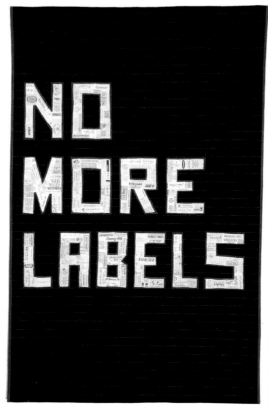

◀ Margaret A. Phillips
Cos Cob, Connecticut, USA

*No More Labels: A Plea for Civil Discourse*
*48 × 32 inches (122 × 81 cm)  |  2017*
*Photo by Jay B. Wilson*

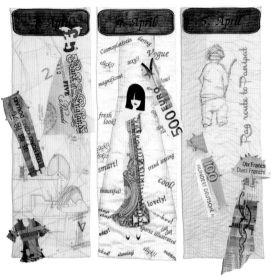

▲ Barbara Lange
Freising, Germany
www.barbaralange.com

*In the Shadows*
*35 × 35 inches (90 × 90 cm) | 2017*

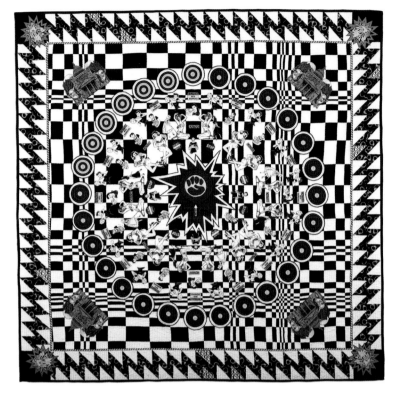

▲ Penny Mateer
Pittsburgh, Pennsylvania, USA
www.pennymateer.com

*You Don't Own Me #14,* Protest Series
*60 × 60 inches (152 × 152 cm) | 2018*
*Photo by Larry Berman*

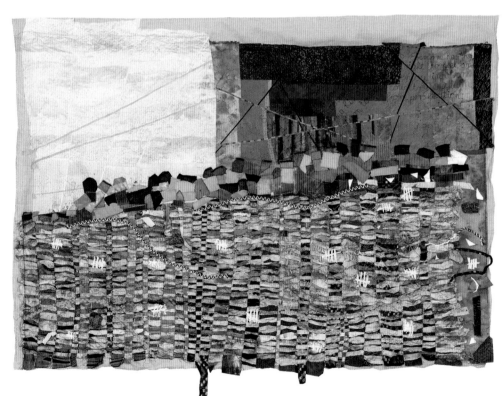

◄ Uta Lenk
Vilsbiburg, Germany
www.justquilts.de

*Everyone has the right (text messages 19)*
*44 × 64 inches (112 × 163 cm) | 2018*
*Photo by Andreas Hasak*

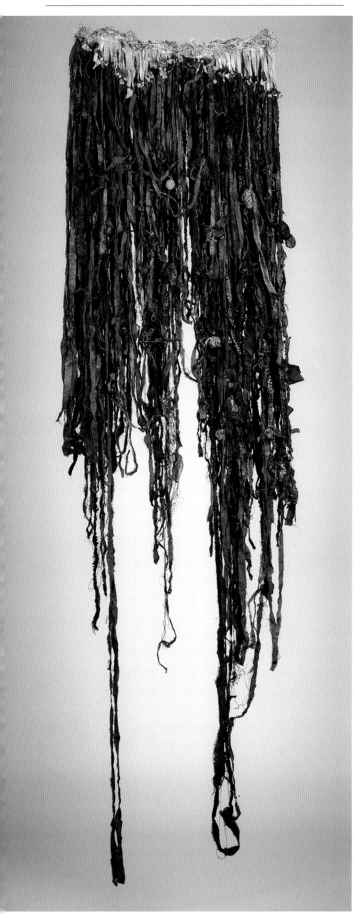

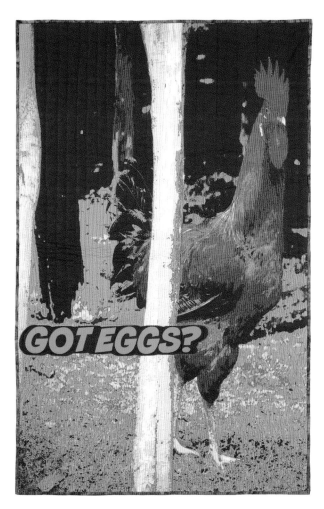

▲ Mary-Ellen Latino
Northborough, Massachusetts. USA
www.highinfiberart.com

*Travel Muse Got Eggs?*
*48 × 36 inches (122 × 91 cm) | 2018*
*Photo by Joe Ofria*

◄ Clairan Ferrono
Chicago, Illinois, USA
www.clairanferrono.com

*Fracking Breaks the Earth's Heart*
*62 × 13 × 2 inches (158 × 33 × 5 cm) | 2017*
*Photo by Daniel Guidara*

# Jayne Bentley Gaskins

RESTON, VIRGINIA

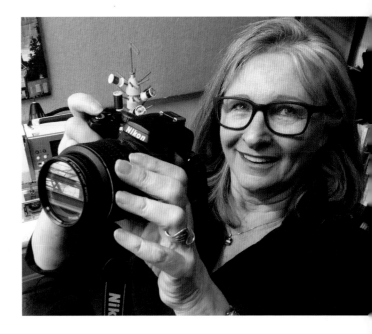

## *Drawn to fiber*

I gained a lifelong love of fiber arts at age five, when my grandmother taught me to knit and crochet. Later, I learned to sew my own clothes and had a blast designing and making my sons' Halloween costumes. I also learned tapestry weaving and even spent a month studying with tapestry artist Maximo Laura in Peru.

These activities were always "fun and games" and a relief from the stresses of school and work. I didn't recognize fiber as a serious art form, and certainly not as a career, until thirteen years ago. I had gone through a difficult period in my life and needed to regroup. I took early retirement from communications with the Centers for Disease Control and Prevention and moved to an island off the coast of Florida. I sought out something creative to do and began to play with fabric. When Ruth Carden, a longtime SAQA member, saw one of my early efforts and told me I had made an art quilt, I was baffled. I didn't know what that was, so she showed me the SAQA website. It opened my eyes.

## *Getting technical*

I design all my art on the computer. My early training is in graphic design, and I love what can be done with photography and digital art, so the computer is a natural tool. I even use it to work out abstract compositions. It allows so much freedom and flexibility. You can experiment to your heart's content and then use the history tool to retrieve a version that worked before you let things get out of hand. When I take the piece to the sewing machine, most of the serious creative work is done; the finish becomes almost mechanical in nature.

*On the Streets Where I Live*
21.5 × 15.5 inches, 2019

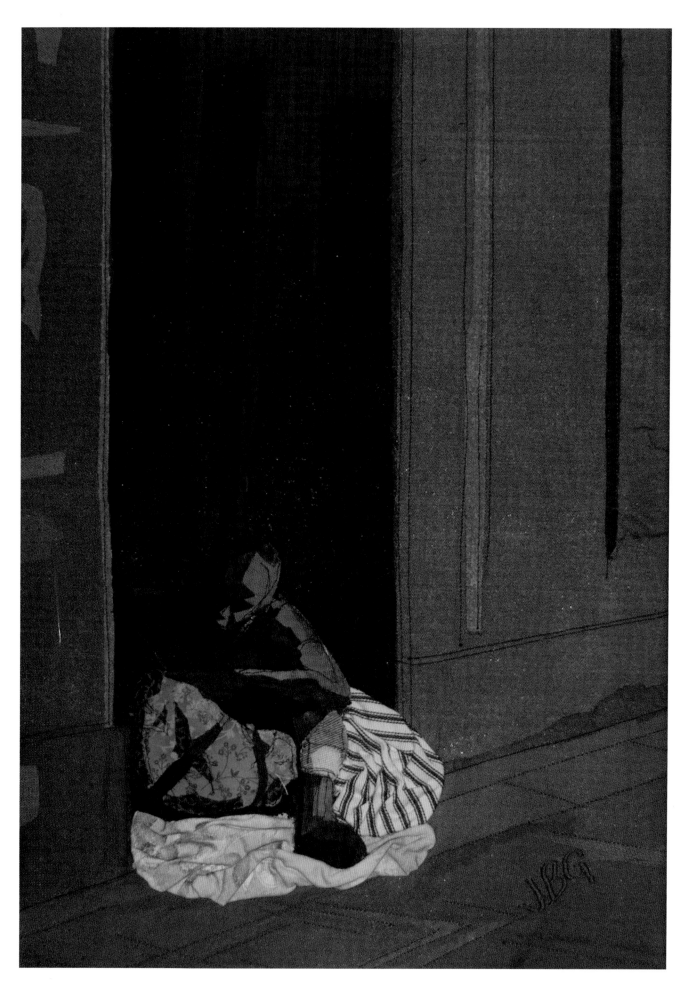

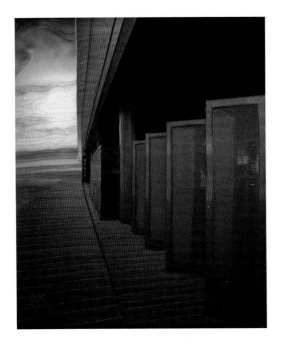
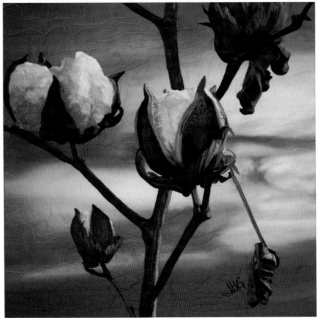

## High relief

I'm intrigued by the relief effects that can be accomplished with fiber, and enjoy marrying this attribute with photographs and digital art. My more pronounced relief effects are thread paintings based on photographs. They are appliquéd on a photographic or digital art background and then stuffed and sculpted with small stitches in a trapunto-like technique. The depth is so pronounced that the piece must be mounted on stretcher bars for stability. I have been pushing the depth of my wall pieces farther and farther, so it's a logical progression that I'm now getting into 3D work. I don't know how long I'll continue in this direction or where it will go from here. I let the art tell me where it wants to go and what it wants to be.

## Inspirational process

I don't look for inspiration; I let it find me. I photograph life around me all the time. Sometimes something as insignificant as an old lock speaks to me, and I can't get it out of my head. Then I know I have to address it in my art. Other times, a call for entry or a political issue takes hold.

When this happens, I first do a lot of research. Then I leave it alone for a while so it can percolate in my subconscious. When I return, I sometimes see my initial ideas as embarrassingly trite, and I replace them with more substantial concepts and designs. Then I "wash, rinse, repeat" until I'm comfortable with both the design and the message.

I deliberately avoid themes. That approach is too restrictive. Each piece is a personal journey, and each viewer is likely to come away with a very different message. I hate writing artist statements because I don't like telling people what to think. If my work stimulates a train of thought in someone else, who am I to tell them they're wrong? The only exception to this is my political work. Here I'm reverting to my previous life in communications where I strive for a strong but clear and simple message. I create two different kinds of artistic expression. The first is personal; the second is public.

*Left:*
*Perspectives*
22 × 18 inches, 2019
(Completed during residency at La Porte Peinte)

*Right:*
*Land of Cotton*
30 × 30 inches, 2015
*Collection of Frank Klein*

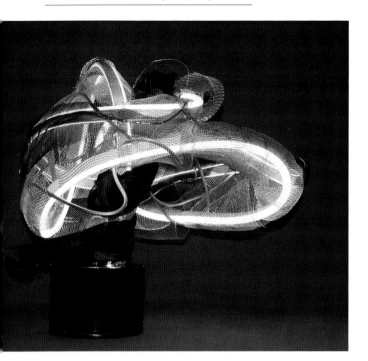

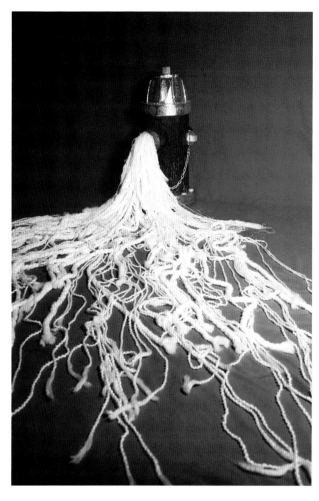

*Left:*
*Spiraling Currents of Golden Light*
13 × 19 × 13 inches, 2019

*Right:*
*The Lowly Fire Hydrant*
23 × 54 × 60 inches, 2017

## New pursuits

In November 2019, I was fortunate to be accepted into an art residency at La Porte Peinte in Noyers, France. I lived with writers, musicians, and other visual artists in a house built in the 1500s, and the shared experience with these other creatives was eye-opening. While I did give a presentation at the end, there was no pressure to produce. We were given the luxury of time and space and encouraged to pursue our own personal creative journeys. As a result, I emerged with a much-deeper understanding of my own creativity and how it is evolving.

I want to see art quilts respected as yet another fine-art medium in the greater world of art. We've made great progress, but we're not there yet. That's why I strive to show my work in multimedia exhibitions. I want a broader audience to see what can and is being done with this fabulously versatile art form.

www.jaynegaskins.com

# Geometric

◀ Ilse Anysas-Salkauskas
Cochrane, Alberta, Canada

*A Game of Life*
*28 × 24 inches (71 × 61 cm)  |  2017*
*Photo by Kestutis Salkauskas*

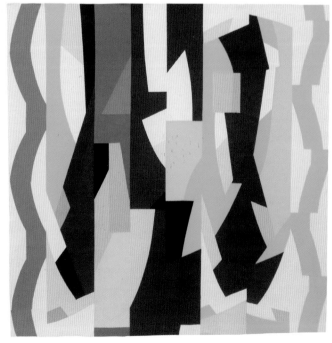

▶ Pat Budge
Garden Valley, Idaho, USA
www.patbudge.com

*Willow*
*81 × 81 inches (206 × 206 cm)  |  2017*

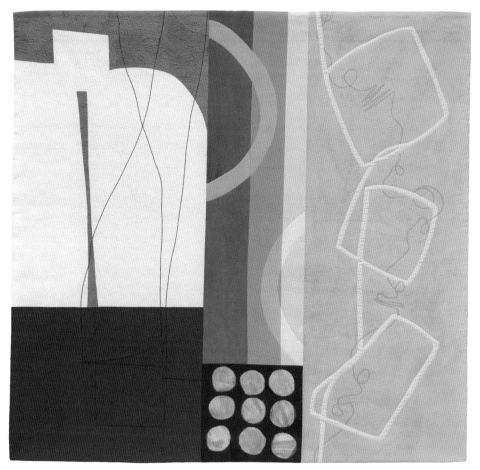

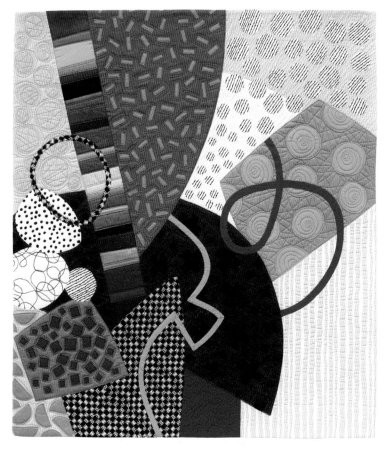

◄ Karen Schulz
Silver Spring, Maryland, USA
www.karen-schulz.com

*Objects in This Mirror*
*67 × 70 inches (170 × 178 cm)  |  2018*
*Photo by Mark Gulezian/Quicksilver*

Diane Melms ►
Anchorage, Alaska, USA
www.dianemelms.com

*Thrill Ride*
*32 × 28 inches (81 × 71 cm)  |  2018*

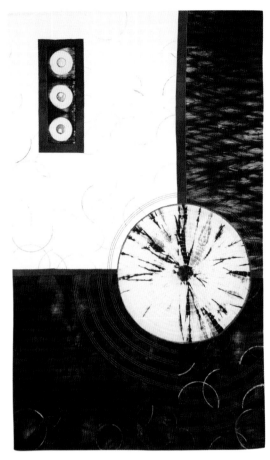

▲ Lyric Montgomery Kinard
Cary, North Carolina, USA
www.lyrickinard.com

*Accession: Something Added*
*50 × 30 inches (127 × 76 cm)  |  2018*

▲ Kate Themel
Cheshire, Connecticut, USA
www.katethemel.com

*Spiraling*
*52 × 34 inches (132 × 86 cm)  |  2019*

◄ Adrienne Yorinks
Juno Beach, Florida, USA
adrienneyorinks.com

*Slanted Blocks / City Hall*
*57 × 87 inches (145 × 221 cm)  |  201*
*Photo by Seve Martine*

▲ Mary Lou Alexander
Hubbard, Ohio, USA
maryloualexander.net

*Big Bang #9*
*53 × 42 inches (135 × 107 cm)  |  2018*
*Private collection  |  Photo by Joseph Rudinec*

▲ Heather Pregger
Fort Worth, Texas, USA
www.heatherquiltz.com

*Shock Melt*
*60 × 47 inches (152 × 119 cm)  |  2019*

▼ Michele O'Neil Kincaid
Strafford, New Hampshire, USA
www.fiberartdesigns.com

*Dancing Colors*
*51 × 82 inches (130 × 208 cm)  |  2018*
*Photo by Scott Bulger*

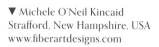

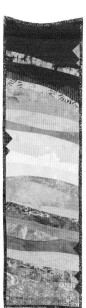
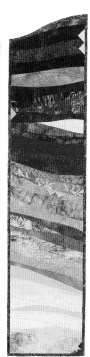
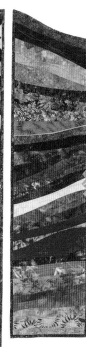

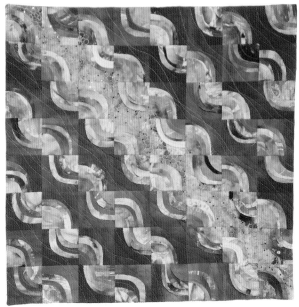

▲ Judith Larzelere
Westerly, Rhode Island, USA
www.judithlarzelere.com

*Cascading Blue*
*60 × 61 inches (152 × 155 cm)  |  2015*

▲ Arlene L. Blackburn
Union Hall, Virginia, USA
arleneblackburn.com

*Brushstrokes: Jasper*
*24 × 24 inches (61 × 61 cm)  |  2019*

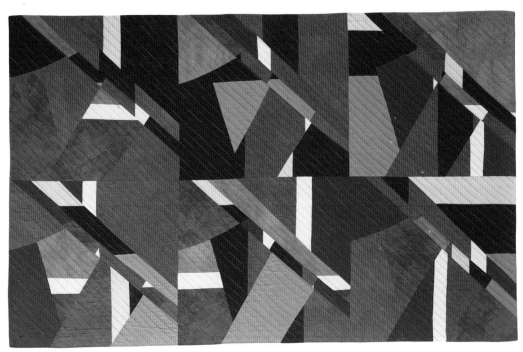

▲ Marcia DeCamp
Palmyra, New York, USA
www.marciadecamp.com

*Tarmac Troubles*
*38 × 57 inches (97 × 145 cm)  |  2018*

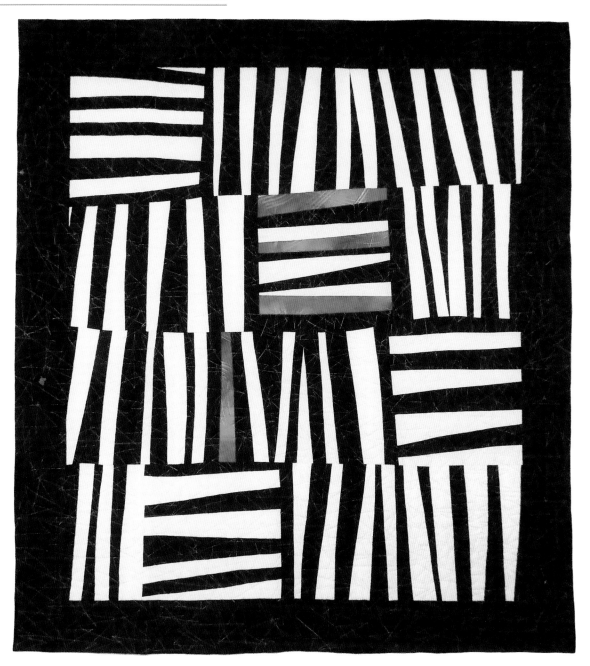

▲ Gunnel Hag
Toronto, Ontario, Canada
www.colourvie.com

*Green is the New Black*
*69 × 63 inches (175 × 160 cm) | 2017*

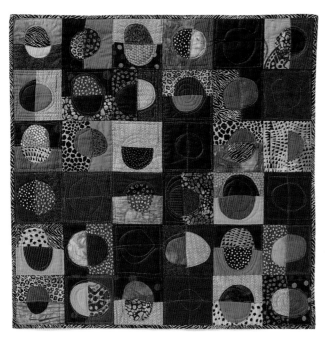

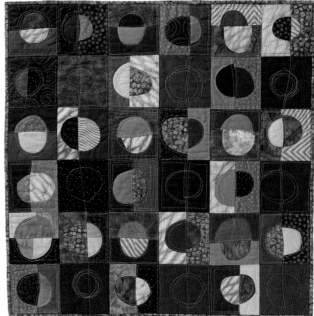

▲ Alison Schwabe
Montevideo, Uruguay
www.alisonschwabe.com

*Sweat Of The Sun; Tears Of The Moon*
*24 × 50 inches (61 × 127 cm) | 2018*
*Photo by Eduardo Baldizan*

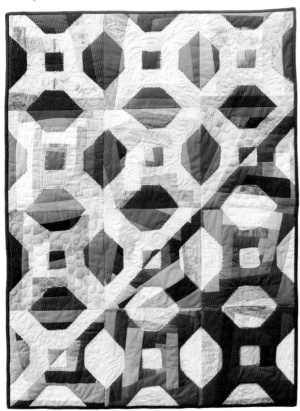

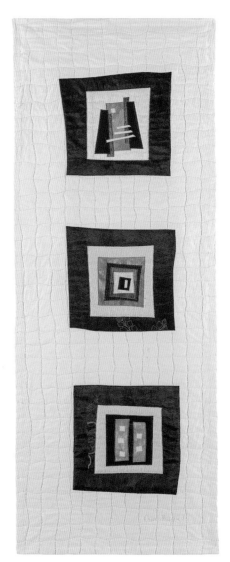

▲ Mary Tabar
San Diego, California, USA
www.marytabar.com

*Jan's XBlock*
*40 × 30 inches (102 × 76 cm) | 2019*

◄ Desiree Vaughn
Elk Rapids, Michigan, USA

*China Memories: The Gate, The Flower, The River*
*75 × 28 inches (191 × 70 cm) | 2018*
*Photo by Gregory Case*

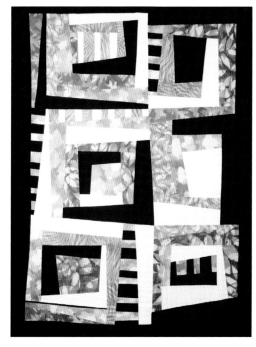

▲ Polly Bech
Swarthmore, Pennsylvania, USA
www.pollybech.com

*Echoes of Gee's Bend*
*49 × 35 inches (125 × 89 cm) | 2019*

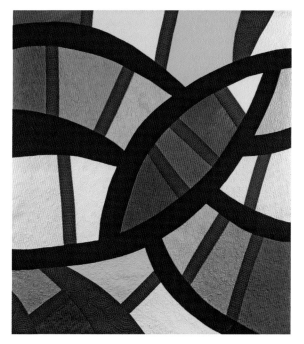

▲ Cindy Grisdela
Reston, Virginia, USA
www.cindygrisdela.com

*Aquarius*
*53 × 47 inches (135 × 119 cm) | 2018*
*Photo by Gregory R. Staley*

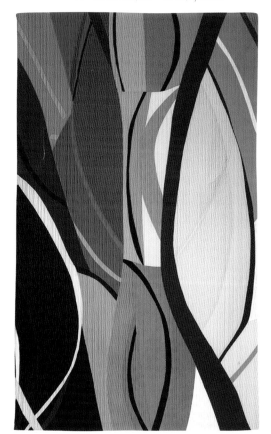

▲ Leslie Tucker Jenison
San Antonio, Texas, USA
www.leslietuckerjenison.com

*Interstitial*
*50 × 30 inches (127 × 76 cm) | 2018*

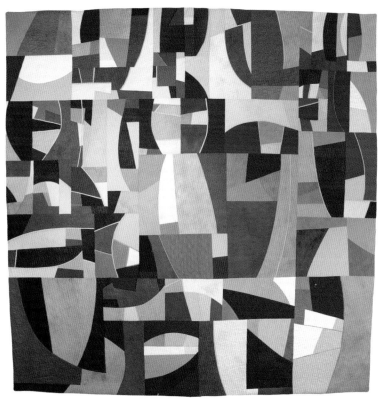

▲ Colleen M. Kole
Grand Rapids, Michigan, USA
www.colleenkole.com

*Time Fragments #20*
*69 × 69 inches (175 × 175 cm) | 2018*

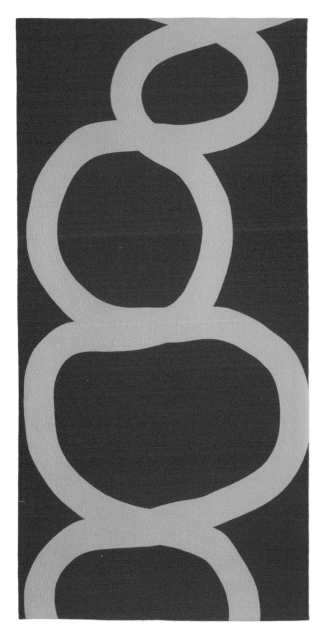

▲ Denise L. Roberts
Albright, West Virginia, USA
www.deniselroberts.com

*Finding Connections #20*
*84 × 43 inches (213 × 108 cm) | 2018*
*Photo by Richard C. Roberts*

▲ Maria Shell
Anchorage, Alaska, USA
www.mariashell.com

*Bear Fence*
*54 × 40 inches (137 × 102 cm) | 2018*
*Photo by Chris Arend*

▶ Benedicte Caneill
Larchmont, New York, USA
www.benedictecaneill.com

*New Work: New York*
*47 × 47 inches (119 × 119 cm) | 2018*
*Photo by Don Hillman*

▲ Judith Quinn Garnett
Portland, Oregon, USA
www.blackdogdesignpdx.com

*Oxidation*
*60 × 65 inches (152 × 165 cm)  |  2018*
*Photo by Owen Carey*

▲ Susan Webb Lee
Fletcher, North Carolina, USA
susanwebblee.com

*Board Game*
*38 × 28 inches (97 × 71 cm)  |  2018*

▲ Hope Wilmarth
Spring, Texas, USA
www.hopewilmarth.com

*Broken Promises*
*33 × 50 inches (84 × 127 cm)  |  2018*
*Photo by Rick Wells, Houston, Texas*

# Art Quilts in Norway: Expanding Opportunities

BY DAISY ASCHEHOUG

Nina Lise Moen
*Fri (Free)*
53 × 47 inches, 2017
*Private collection*

Norwegian quilt artists are forging new ground in a country that is much more known for tapestries and knitted sculptures than quilted works of art. Still, they create and are eager to show their work.

Norwegians describe the art quilt in much the same way as the larger art quilt community around the world. When writing for *Norske Quilteblad*'s issue on art quilts, quilter Maria Vetter Christiansen says that a quilt is three layers of fabric held together with thread. The more specific "art quilt" can be defined by stating what it is not: a reproduction of another artwork or a quilt made from a pattern. Christiansen goes on to add that while an art quilt can be functional, that function isn't the meaning of the quilt—it

Turid Tønnessen
*Reflection in Green*
32 × 46 inches.
2017
*Photo by NQF*

neither detracts nor adds to its status as art. And, she says, "Art must be experienced. It should provoke and tell a story that is relevant to the audience, which they can recognize."

In *Free*, Nina Lise Moen of Stavanger conveys a story with the selection of the various layers, colors, and symbols of her quilt. The background is a children's fabric underneath several layers of recycled transparent materials that have been cut into three repeated shapes. The shapes are repeated to the extent that it is difficult to discern between a character in the story and the background. This translucency through which things can be seen culminates in the bits of red organza in the lenses of the glasses. The frames of the glasses are from a cotton hat. All of the work is covered in a layer of tulle and quilted densely with organic, horizontal lines. Moen's main style is slightly more whimsical, as seen her book *Gledesspredere* ("Spreading joy"), and she teaches workshops in Stavanger.

In a 2017 *Norsk Quilteblad* article, Turid Tønnessen describes the lack of an art quilt environment in Norway. Educated as a textile printer, she continues to work with dyeing and printing, using Procion products and experimenting with rust and seaweed. Tønnessen has shared work at large quilt festivals in other countries, including the United Kingdom,

France, Italy, and Switzerland. She exhibits elsewhere so often that she jokes about her struggle to keep track of where her work is. Because she operates so often in the larger European environment, she has many works with only English titles. At her last exhibition, Tønnessen sold three large pieces and almost all of the small works.

Signe Haugen had an interest in quilting at an early age and began quilting in 1985. Her work moves toward the pictorial with her portrayal of nature scenes against a subtle geometric grid. Haugen, who lives in Bergen, uses a watercolor technique in her work where each square in her scenes finishes at about 1 inch. Haugen teaches workshops throughout Norway, and her work has been included in various quilt shows and magazines.

Sølvi Krokeide works in a similar method, creating landscapes and portraits with small geometric shapes and almost painterly effects. *Aurora Borealis* won first prize and audience awareness at the QuiltExpo in The Hague in 2004. The slightly pixelated scene shows dark, impressive mountains and the vivid colors of the Northern Lights, both quintessentially Norwegian.

Turid Lismoen creates her pictorial quilts from photographs she takes during her travels. Early on in her art quilt career, Turid was influenced by artists

Turid Lismoen
*Betelnuts and Rice Wine*
28 × 40 inches

Kjersti Thoen
*Tetraeder (Triangle)*
46 × 40 inches, 2019

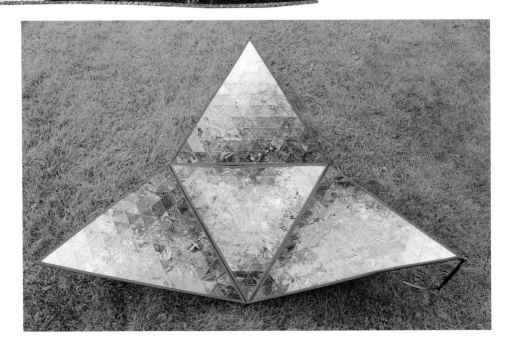

Ruth McDowell, Katie Pasquini Masopust, and Kaffe Fassett. Lismoen uses her background as a graphic designer to break down her photographs into smaller pieces for appliqué. Her finished works have traveled in Europe and won awards. Last year, Lismoen's pictorial quilt *Betel Nuts and Rice Wine* won First Prize, Best Handiwork, and Visitors' Choice awards at the Norwegian Quilt Association's annual show. Her artwork then went on to represent Norway in the European Diversity exhibit at the Festival of Quilts in Birmingham in 2018. The quilt is based on a photograph she took on a trip to Vietnam in 2017.

Bente Kulltorp Andersen's pictorial work contains a combination of commercial and hand-dyed fabrics. Before her death, Andersen documented her process on her blog. She stressed that it was important to have enough tones to work with, which is why she was so fond of dyeing her own fabrics. Andersen's *Dassehra* won Highly Commended and Judge's Choice awards at the Festival of Quilts in 2011, and *Aweleye* won Highly Commended in the same show in 2010.

After creating a series of textile works inspired by poetry, Iina Alho learned of art quilts and

realized this medium was her calling. Alho prefers to work in a smaller scale, less than 25 inches in height and width, and her preferred techniques include fusing, appliqué, free-motion quilting, and thread painting. Regarding her inspiration, Alho says, "I treasure the moment when I read or hear something that instantly inspires me, and I just know that the process of sewing a new art quilt has started. My desire with each of my art quilts is to convey hope and comfort, so my artistic process isn't really over until the art quilt has found its new owner." Alho sells her work online throughout the year but has a higher number of sales during her biennial exibitions in Hamar.

Kjersti Thoen has been quilting since 1992. Thoen began as a traditional quilter but realized soon that she wanted "to create textile art with quilts as my chosen form." Thoen's style is experimental and is influenced by artists Ruth B. McDowell and Solveig Refslund. Thoen participates each year in the Norwegian Quilters Guild's (NQF's) competition and has had quilts in Nordisk Quiltetreff in Norway, Denmark, Sweden, and Finland. She's also exhibited work at the Festival of Quilts in Birmingham, and in France, Italy, and the United States. Her latest exhibited work is *Triangle*, a three-dimensional piece.

Eldrid R. Førde enters many of her quilts in local and national shows because of the difficult logistics of shipping abroad. Occasionally, she has pieces in galleries. Førde's recent work consists of commissions such as school banners and liturgical vestments for churches. Førde says, "They are very time consuming, especially the planning process, and regarding the liturgical pieces, there is also a lengthy approval process. I have loved the challenges of these commissions, but as I am getting on in age, I have decided to stop taking them on so I can have more time and energy to work freely on my own ideas."

Inger-Ann Olsen has sewn all her life and has made art quilts for the last twenty years. Olsen utilizes several different surface design techniques in her work. After using dye, silkscreen, rust, or painting,

Iina Alho
*Å Leve (To Live)*
21 × 20 inches, 2019

Inger-Ann Olsen
*SK 537 HAM - OSL*
24 × 16 inches, 2017
*Collection of the international project TEXNET I*

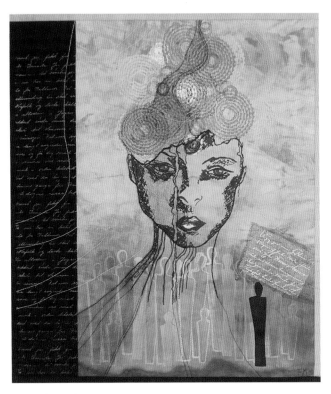

Frøydis Myhre
*Slektskap I (Kinship I)*
21 × 23 inches, 2010

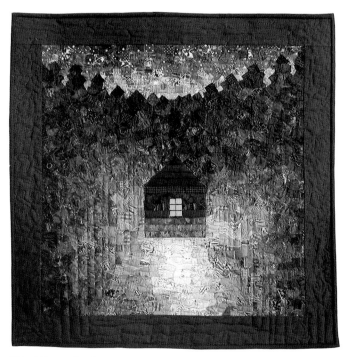

Eldrid Røyset Førde
*Blue Night*
24 × 24 inches, 2006

Olsen finishes her art with machine or hand stitching. Over the last decade, Olsen has explored rust dyeing, and lately she has combined this technique with tea dyeing and slow stitching. Olsen is participating in TEXNET 2, an international group of twenty textile artists from Europe, the United States, and Australia collaborating and exhibiting over a two-year period. Olsen previously participated in STING Art Quilt and is currently participating in ARTiNOR.

STING Art Quilt is a group of artists including Ragnhild Kjenne, Ingunn Kjøl Wiig, Merete Veian, Inger-Ann Olsen, Merete Nybro Berg, and Bente Andersen Sundlo. This group existed from 2001 until 2017, exhibiting at the European Patchwork Meeting in Alsace, France, in 2014, Luxembourg in 2016, and the Prague Patchwork Meeting in 2017. ARTiNOR is a Norwegian art quilt group established in 2018 that will exhibit in Prague in 2020. Current members include Frøydis Myhre, Inger-Ann Olsen, Elisabet Saksen, Bente Andersen Sundlo, and Turid Tønnessen.

Textile arts are held in high regard in Norway, but even though whole galleries are dedicated to textiles, few of them accept quilts. As more artists choose to work with quilts, the network and exhibition opportunities locally will grow. In the meantime, the lack of a large local art quilt scene does not deter these talented artists from creating.

*Editorial note: not all pieces could be shown with this article.

*Daisy Aschehoug is an award-winning quilt designer living in Nesodden, Norway. Her passion centers on the art of modern traditionalism and incorporating curved piecing into utility quilts. She teaches a variety of workshops, including beginning sewing, curved piecing, and using technology to design quilts. Her quilts have been included in more than a dozen magazines and in two book compilations:* Modern Home and Modern Quilts: Designs of the New Century. *She recently published* Quilt Modern Curves & Bold Stripes *with Heather Black.*

INTERVIEW WITH

# Patty Kennedy-Zafred

MURRYSVILLE, PENNSYLVANIA

All photos by Larry
Berman

## *Developed interest*

The photographic image has always been a passion for me. As a child, I was captivated by the pages of *Look* and *Life* magazines with their big, glossy pages. I experimented in my own darkroom during college and for several years thereafter. I carried my camera wherever I went, developed my own film, and printed the images. That darkroom was a magical place. Today, I feel the same sense of wonder when I silkscreen images onto fabric.

My educational background is in journalism and photography, so storytelling became the natural basis for my work. While the images I select express a story, they also allow the viewer to see the work through the lens of their own experiences, memories, and emotions. In several works, news articles or text graphics from the relevant time period are included to foster understanding.

A large majority of my historical images come from the Library of Congress Prints & Photographs Online Catalog. If the file available for download is small, a higher-resolution file can be ordered. It is important that any image I utilize in my work be free of copyright. For contemporary images, I obtain written permission for use; the same with older images that may still be protected by copyright.

Converting photographic images to silkscreens is a complex process. Prior to making the screens, I correct, crop, and size the images in Photoshop. Many vintage images have flaws or distracting backgrounds that need to be removed. The image file size needs to be reasonably substantial to produce a high-quality silkscreen. I am fortunate to have Artists Image Resource in Pittsburgh as both a technical resource and print studio in which to work.

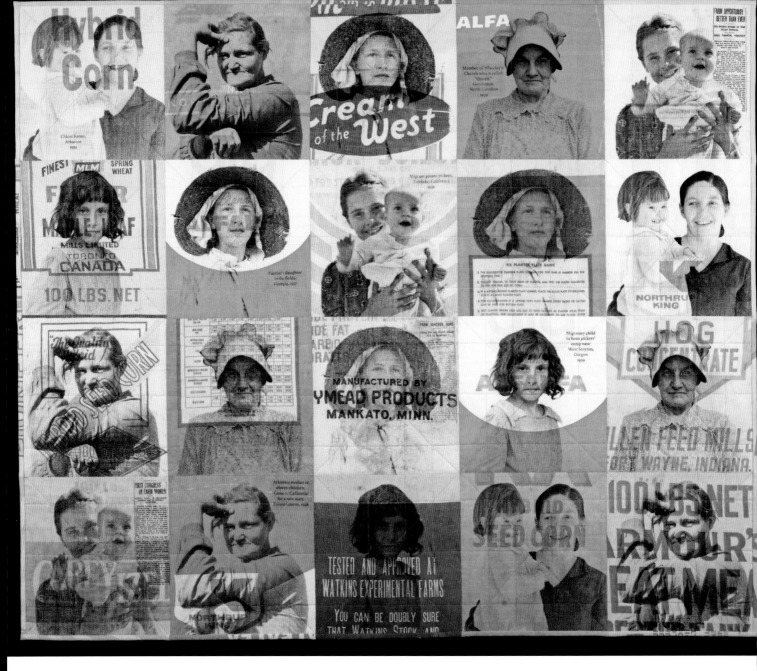

## Fine tuning

My art reflects my interest in people, their stunning diversity, personal struggles, and place in history. Many quilts from the past decade feature men and women in roles that no longer exist or are fading: family farmers, coal miners, and steel workers. They are reminders of our country's past. In the Native American, Japanese Internment, and child labor series, they also reflect dark times in our history. The quilts featuring contemporary images of African women, taken by Dietmar Temps, present startling contrasts in culture, beauty, and tradition in today's modern world.

Most of the images chosen are historical, which is a step away from earlier work that featured personal photographs. Now, whether using vintage photos, postcards, or the work of contemporary photographers, my subject matter can vary. Typically, one image captures my heart. I then expand the story with accompanying photographs that were taken during the same period or by the same photographer.

*American Portraits: Heart of the Home*
57 × 68 inches, 2019
*Images courtesy of Library of Congress*

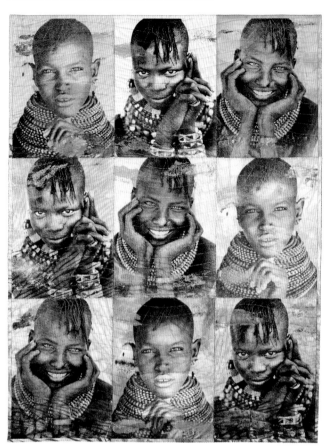 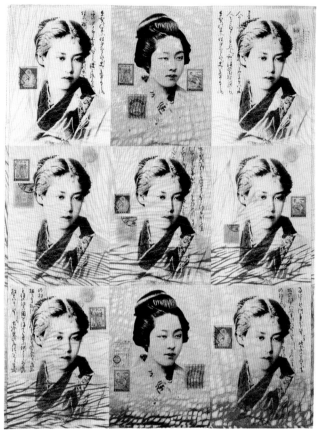

*Left:*
*The Jewels of Kenya*
45 × 33 inches. 2017
*Images courtesy of Dietmar*
*Temps, with permission*

*Right:*
*A Separate Reality*
48 × 36 inches. 2016
*Images from vintage postcards*

Some of my quilts develop into a series, either because the images remain compelling or because I want to improve upon the previous work by presenting it in a new way. My recent American Portraits series uses images of farmers from the Dust Bowl era silkscreened onto vintage feed sacks. The feed sacks are a challenge, in both their acquisition and preparation for printing. Printing each one is a wild card, as no two are the same weight or weave.

My work takes many twists and turns throughout the process, especially on the design wall. I attempt to lay out the dyed fabrics on the wall, prior to printing, and work in Photoshop with image arrangements. But once the pieces are printed, they often take on a totally different result than anticipated. I use my iPhone to capture various arrangements, convert the image into black and white to discover the values, and then rearrange. This can take days, or sometimes weeks, with the size of the piece also varying and changing.

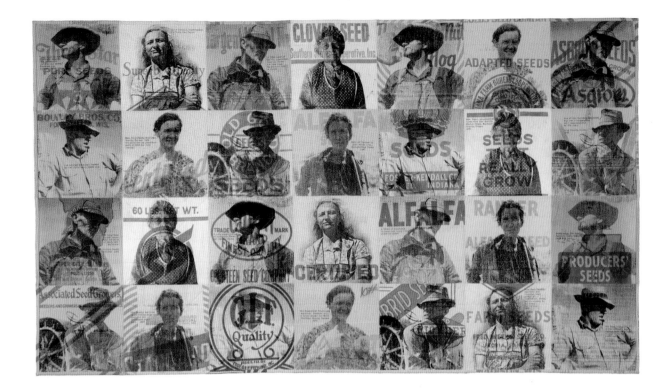

## Recent projects and accomplishments

I recently completed two projects for an invitational exhibition celebrating the 100-year anniversary of women's right to vote, which features silkscreened images of suffragettes on hand-dyed fabric. There are several individual marchers, all of whom reflect very distinct, determined personalities.

My exploration with accordion books has continued; I just finished one for an invitational exhibition that will be displayed in front of a related piece hanging on the wall, adding more complexity and interest to the installation. As part of my American Portraits series, realizing that most of the previous quilts featured men and boys, I have completed additional pieces highlighting women, young and old, an important addition.

It is always wonderful to be accepted into exhibitions; however, I am very honored to have been nominated, and selected, as a Master Visual Artist in Southwestern Pennsylvania. Only ten artists are chosen every five years, and I was the only textile artist among the honorees of painters, sculptors, etc., which was particularly satisfying to me personally. A stunning exhibition of all selected artists was held at the Sen. John Heinz History Center, and one of my featured quilts was accepted into the permanent collection of the center.

Lately, I feel on the cusp of change. I have taken additional tutorials to learn to create multicolor silkscreens, which I hope will result in more complex images and layered backgrounds. Future series may again include my own photographic images to create new stories that reflect on personal experiences.

*American Portraits: The Family Farm*
44 × 77 inches. 2015
*Images courtesy of Library of Congress*

pattykz.com

*Coal Town: Second Shift*
60 × 60 inches, 2018
Images courtesy Library
of Congress.

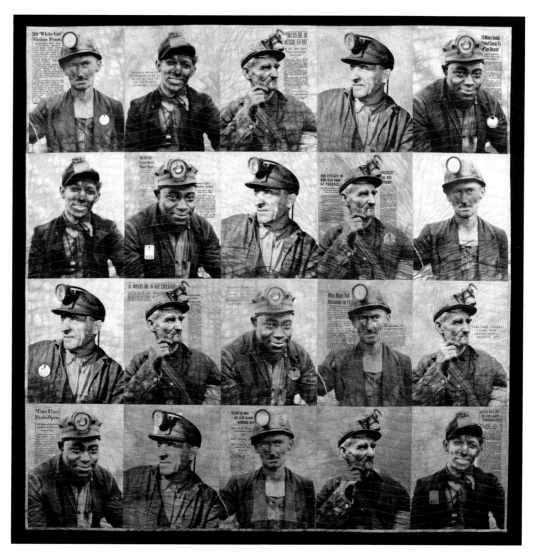

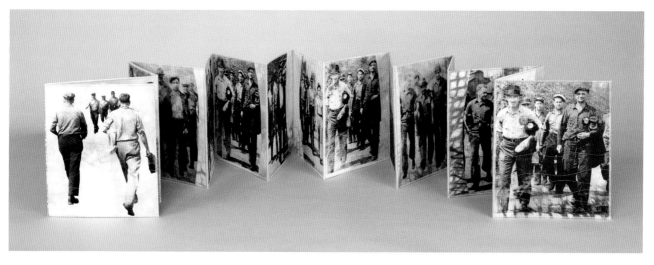

*Shift Change*
12 × 36 × 25 inches, 2018
Images courtesy Library of Congress

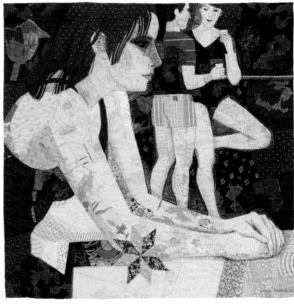

# Layered & Stitched:

## 50 YEARS OF INNOVATIVE ART

A showcase of fifty art quilts by renowned master artists, these seminal works show the evolution of the art quilt from the earliest pioneers creating during the 1960s through to today's artists experimenting with new forms, new materials, and new digital technologies.

Viewers are able to trace the development of this exciting art form as it developed from isolated makers, primarily in Ohio and California, into an international movement involving thousands of artists spanning the globe.

Leslie Gabriëlse
Rotterdam, Netherlands
http://gabrielse.com

*Star*
48 × 48 inches | 1995

*Collection of San Jose Museum
of Quilts & Textiles
Gift of Penny Nii and Edward
Feigenbaum
Photo by James Dewrance*

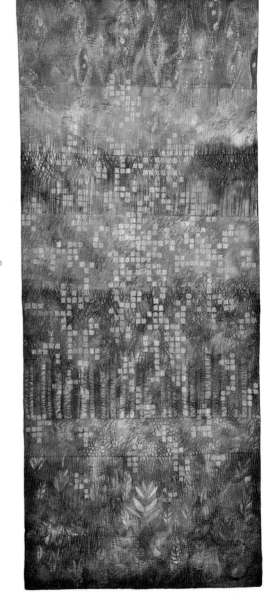

Deidre Adams
Littleton, Colorado, USA
https://deidreadams.com

*Returning to the Source*
78 × 32 inches | 2012

*Left to Right:*
Elizabeth Busch, USA; *Warm Light,*
1980
Nancy Crow, USA; *Study #11,* 1990
Laura Wasilowski, USA; *Blue Book on
Blue Chairs,* 1995

Layered & Stitched: 50 Years of Innovative Art at the Texas Quilt Museum

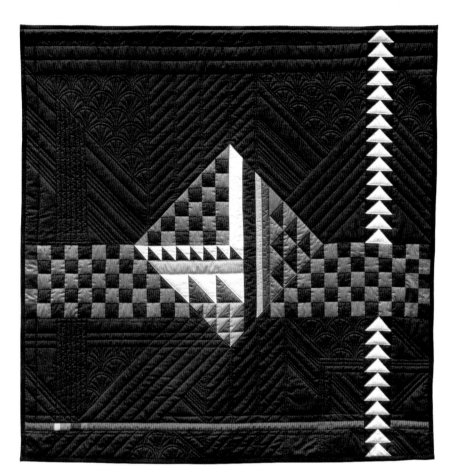

Charlotte Yde
Frederiksberg, Denmark
http://www.yde.dk

*Steen's Quilt*
59 × 59 inches | 1979
*Photo by Steen Yde*

Alice Beasley
Oakland, California, USA
https://www.alicebeasley.com

*No Vote, No Voice*
60 × 36 inches | 2014

Ulva Ugerup
Malmö, Sweden

*Angels of Wrath*
29 × 44 inches | 2008
*Photo by Deidre Adams*

Nancy Crow
Baltimore, Ohio, USA
http://www.nancycrow.com

*Study #11*
17 × 17 inches | 1990
*Photo by Deidre Adams*

Carolyn Mazloomi
West Chester, Ohio USA
http://www.carolynlmazloomi.com

*Certain Restrictions Do Apply*
62 × 54 inches | 2013

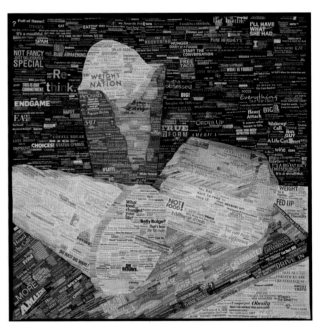

Pixeladies
Sacramento, California, USA
http://www.pixeladies.com

*American Still Life: The Weight of the Nation*
60 × 60 inches | 2012

Katie Pasquini Masopust
Fortuna, California, USA
http://www.katiepm.com

*Spring Equinox*
60 × 53 inches | 2014

Michael James
Lincoln, Nebraska, USA
https://michaeljamesstudioquilts.com

*Bouree*
46.5 × 46.5 inches | 1992
*Collection of San Jose Museum of Quilts & Textiles*
*Gift of Penny Nii and Edward Feigenbaum*
*Photo by James Dewrance*

# Sense of Place

▲ Giny Dixon
Danville, California, USA
www.ginydixon.com

*Coastal Passage: Beautiful Victim*
*42 × 43 inches (105 × 109 cm)  |  2018*
*Photo by Sibila Savage*

▲ Joanne Alberda
Sioux Center, Iowa, USA
joannealberda.com

*Passages: Coming Through*
*40 × 20 inches (102 × 51 cm) | 2017*

▲ Susan V. Polansky
Lexington, Massachusetts, USA
www.susanpolansky.com

*An Ordinary Day*
*50 × 30 inches (127 × 76 cm) | 2018*
*Photo by Boston Photo Imaging*

▶ JoAnn Camp
Greenville, Georgia, USA

*Descending Blood Mountain*
*30 × 30 inches (76 × 76 cm) | 2018*
*Photo by Kenny Gray*

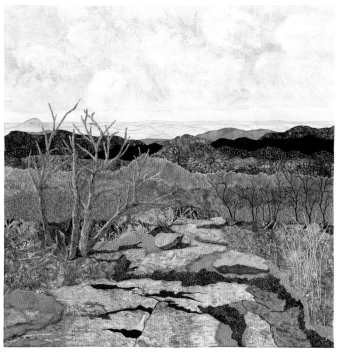

▲ Ellie Kreneck
Lubbock, Texas, USA
kreneckstudios.com

*Moonrise in a West Texas Canyon*
*40 × 30 inches (102 × 76) | 2017*

▲ Annette Kennedy
Longmont, Colorado, USA
www.annettekennedy.com

*Flatirons Symphony*
*22 × 29 inches (55 × 72 cm) | 2018*
*Photo by Van Gogh Again*

▲ Pat Bishop
Shawano, Wisconsin, USA
patbishop.inf

*Bedroom in My House*
*12 × 12 inches (31 × 31 cm) | 2017*

▲ Dorothy Raymond
Loveland, Colorado, USA
www.dorothyraymond.com

*Solitude*
*29 × 53 inches (74 × 135 cm) | 2018*
*Collection of Eliz and James Albritton-*
*McDonald | Photo by Allan Snell*

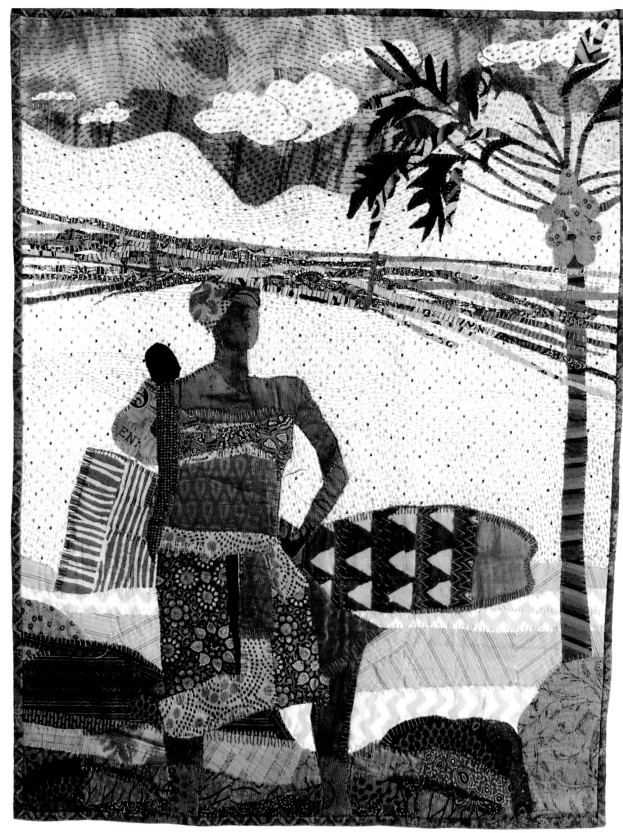

▲ Pamela Gail Allen
Kingston, Ontario, Canada
www.pamelart.com

*FFFF*
*35 × 28 × 1 inches (89 × 71 × 3 cm)* | *2018*

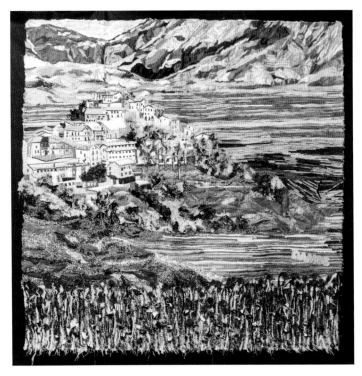

▲ DAMSS Daniela Arnoldi and Marco Sarzi-Sartori
Milano, Italy
www.damss.com

*CASTELLUCCIO the ghost town*
*59 × 59 inches (150 × 150 cm) | 2017*
*Private collection*

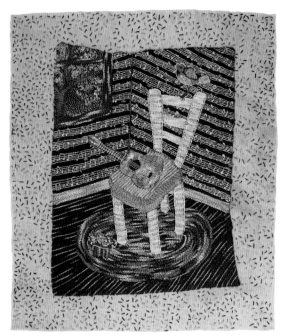

▲ Laura Wasilowski
Elgin, Illinois, USA
www.artfabrik.com

*Musical Chair*
*14 × 12 inches (34 × 29 cm) | 2018*

◄ Amelia Leigh
Southwick, West Sussex, UK
www.amelialeightextiles.co.uk

*In the Street*
*49 × 26 inches (125 × 66 cm) | 2019*
*Private collection | Photo by Katie Vandike*

▲ Sue King
Lancaster, Ohio, USA
www.suekingarts.com

*A River Runs Through It*
*12 × 31 × 2 inches (31 × 79 × 4 cm)  |  2018*
*Photo by Rob Colgan*

▲ Linda Anderson
La Mesa, California, USA
www.laartquilts.com

*A Day in the Life*
*47 × 113 inches (114 × 287 cm)  |  2019*
*Photo by Jamie Hamel-Smith*

▲ Sharon Collins
Arnprior, Ontario, Canada
www.sharoncollinsart.com

*Sublime*
*35 × 27 inches (89 × 69 cm) | 2018*
*Private collection*

▲ Jeannie Palmer Moore
Kerrville, Texas, USA
jpmartist.com

*Wrightsville Pier*
*48 × 36 inches (122 × 91 cm) | 2017*
*Photo by Bob Hill*

▲ Heather Dubreuil
Hudson, Quebec, Canada
www.heatherdubreuil.com

*View from Riga Cathedral*
*24 × 18 inches (61 × 46 cm) | 2018*

▲ Deb Plestid
Tatamagouche, Nova Scotia, Canada

*MacKay Barns Standing Still on Spiddle Hill*
*30 × 45 inches (76 × 114 cm) | 2019*

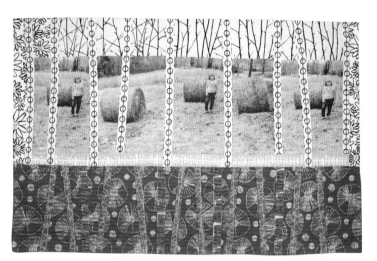

▲ Catherine Whall Smith
Chaplin, Connecticut, USA
www.catherinewhallsmith.com

*Get Me Out of Here ... Please*
*23 × 36 inches (58 × 90 cm)* | *2018*

▲ Jill Kerttula
Charlottesville, Virginia, USA
www.jillkerttula.com

*Urban Voyeur: night on 2nd and Water*
*50 × 39 inches (127 × 98 cm)* | *2019*

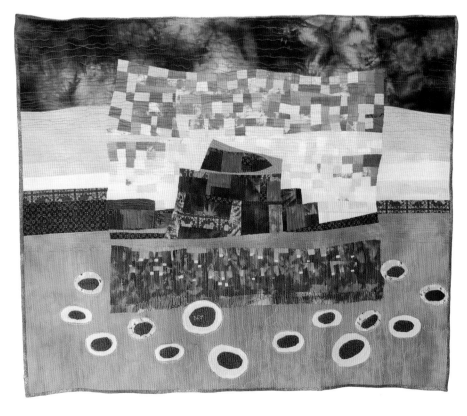

Sylvia Weir ▶
Beaumont, Texas, USA
www.sylviaweirart.com

*Hwy 288 Capulen*
*36 × 48 inches (91 × 122 cm)* | *2018*

▲ Valerie S. Goodwin
Tallahassee, Florida, USA
www.valeriegoodwinart.com

*Cartographic Collage VI*
*48 × 36 inches (122 × 91 cm)*
*(diptych; dimensions are for each piece) | 2018*
*Photo by Barbara Davis*

▲ Sara Sharp
Austin, Texas, USA
www.sarasharp.com

*Winter Shadows*
*31 × 44 inches (79 × 112 cm) | 2018*

▲ Eileen J. Williams
Cedar Point, North Carolina, USA
www.eileenfiberartquilts.com

*Beach Comber*
*31 × 19 inches (79 × 48 cm) | 2018*
*Private collection*

▲ Denise Labadie
Lafayette, Colorado, USA
www.labadiefiberart.com

*Bonamargy Friary*
*61 × 42 inches (155 × 107 cm)* | *2018*

▲ Natalya Khorover Aikens
Pleasantville, New York, USA
www.artbynatalya.com

*Iron Spine 5XL*
*77 × 51 inches (196 × 130 cm)* | *2017*

◀ Geri Patterson-Kutras
Morgan Hill, California. USA
geripkartquilts.com

*The Neighborhood*
*48 × 36 inches (122 × 91 cm)* | *2018*
*Kaiser Hospital* | *Photo by Gregory Case*

# Susie Monday

PIPE CREEK, TEXAS

## *Art quilts or bust*

I stumbled into the world of art quilts when, having amassed a pile of art cloth, I took a workshop with Sue Benner and learned about fusible webbing. My eighth-grade home economics teacher had told me that I was a hopeless seam-stress. But after Sue's class, I dusted off my grandmother's old Singer and went at it. I can't match corner points or make a decent border. So I don't.

Self-defined as an artist since I was six years old, I was a studio painting major in college but always gravitated toward collage. I spent thirty-five years in arts education, journalism, and exhibition design and administration at a children's museum. When I turned fifty, I decided that if I were to realize my dream role as an artist, I had to stop working full time for other people, no matter how creative the work was. It was time for a new career path.

Today, I have cobbled together the life of a teaching artist, both in person and online. My art quilt career could not have happened without the internet, International Quilt Festival / Houston, Studio Art Quilt Associates, and support from friends, family, collectors, and students.

I like working in the world of fiber arts because it allows me to use many skills and interests: painting, printmaking, embroidering, building, layering, embel-lishment, and collage. Working in fabric also binds me to generations of women. I honor these connections and celebrate them in content and form.

*Seven Days, Six Weeks*
65 × 50 inches, 2020

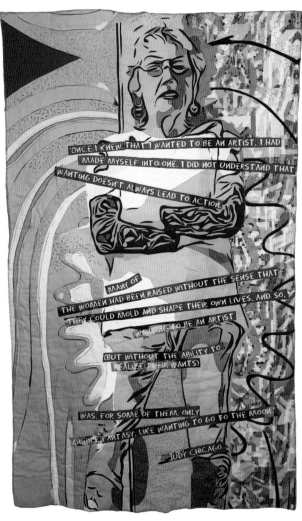

The text on the right-hand quilt reads:

"ONCE I KNEW THAT I WANTED TO BE AN ARTIST, I HAD MADE MYSELF INTO ONE. I DID NOT UNDERSTAND THAT WANTING DOESN'T ALWAYS LEAD TO ACTION. MANY OF THE WOMEN HAD BEEN RAISED WITHOUT THE SENSE THAT THEY COULD MOLD AND SHAPE THEIR OWN LIVES, AND SO, WANTING TO BE AN ARTIST (BUT WITHOUT THE ABILITY TO REALIZE THEIR WANTS) WAS, FOR SOME OF THEM, ONLY A IDLE FANTASY, LIKE WANTING TO GO TO THE MOON. —JUDY CHICAGO"

## Fusing high, low tech

I often use fabric I design on my iPad with special-effects apps and editing software. The resulting design is printed on fabric by a digital-printing vendor. I use that fabric in combination with surface-designed fabrics that I have printed, stamped, or hand-dyed, many times starting with vintage fabrics or upcycled clothing from a thrift store. Rescuing discarded, embellished, embroidered, and ethnic textiles is a real passion of mine.

Conversations between color and texture are the first step in my process. Next comes inspiration from the drama of pattern in everything I see around me: the wind in the cedar trees below my windows, the Guatemalan and Mexican textiles in my studio, the angels who come to me as I work. I make textile paintings—art quilts—and art cloth, stacking up stashes of the latter in order to make the former.

My signature work often tells a story since the space is filled with complexity and pattern. My work has evolved as I've gained skills and found good ways to combine stitch with cut fabric, but it's still very improvisational.

I have a number of ongoing series. All of them reveal personal stories, and some include personal iconic imagery. Although my more recent work is abstract and nonrepresentational, it's usually linked to a story running through my head.

*Left: Borderlands Guadalupe*
50 × 32 inches, 2018

*Right: Judy Chicago*
50 × 30 inches, 2019

*Opposite:*
*Top: Firestorm*
40 × 58 inches, 2018

*Bottom: On the Day You Were Born: The Sun Flared*
40 × 78 inches, 2019

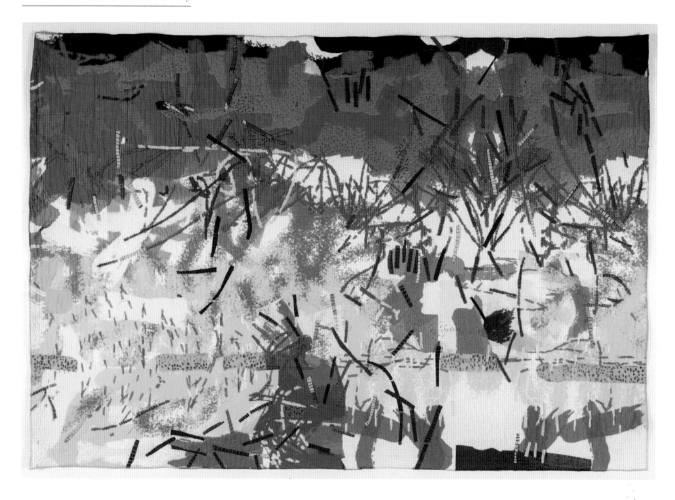

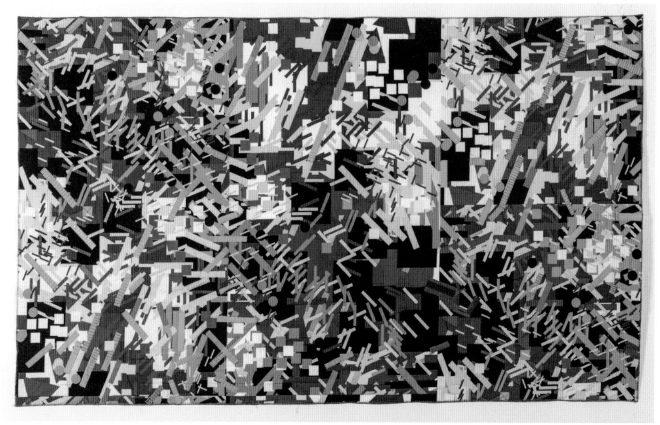

I think many people are surprised at my leap into abstract compositions. I continue to work on my narrative series and landscapes, but I'm having a blast taking inspiration from the abstract expressionists who were such loud voices in my art education in the 1960s. Making these large, immersive, overall compositions lets my love of color run riot!

Large, abstract pieces are currently engaging my imagination. I responded to the pandemic with a composition that contains daily "patches" that include the numbers of cases, deaths, and recoveries. It still remains to be seen what this will become, but I think it captures the chaos and uncertainty we have been living with.

## Tales and themes

An important theme in my work is humanity's creative process as it appears in nature and as it relates to the universe. I consider myself a co-creator of the world, depicting the seasons and pathways that bind us to the planet. What are the life lessons I'm here to learn, appreciate, and make visible?

My art often tells the spiritual and metaphysical stories in my life and what I observe in the lives of other women. My work is about everyday occurrences: our visions, hopes, dreams, and frustrations, and the secret spaces in our hearts where wisdom is found. The paths are both literal and metaphorical, roads I have walked and dreamed about.

## On the horizon

I make art as a manifestation of creative energy. Because I teach, I want to model good creative action. To do so, I have to be a serious maker, so I make and keep my appointments in the studio. We sometimes forget that we are creators and co-creators of our days, our environment, and our pathways. We live in a consumer-oriented, social-media, quick-fix world, but most art, science, politics, and worthwhile actions require time and the ability to slow down and pay attention.

I want my art to inspire others to take creative action with their own stories, whether that happens with words, paint, cloth, cameras, or any other medium that fits the tale.

susiemonday.com

# Metamorphosis

Metamorphosis generates transformative change in shape, nature, or structure. Animals physically develop and change from birth to maturity. Concepts and ideas morph and change over time. Even the earth's landscape progresses through many geological and ecological stages.

Change may be positive, negative, frightening, or enlightening. The pieces in this exhibition demonstrate the inevitability of change—physical, philosophical, or personal—and the results of such transformations, no matter how subtle.

Kathy Brown
Modbury, South Australia, Australia

*Growing Pains*
56 × 42 inches | 2014

Amanda Miller
Eugene, Oregon, USA

*Dilemma*
55 × 35 inches | 2016
Photo by Jon Meyers

Bella Kaplan
Kfar-Giladi, Israel, Israel
https://www.bellakaplan.com

*Philodendron*
47 × 36 inches | 2018
Photo by Dror Miller

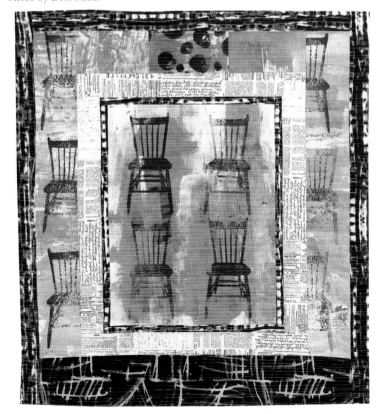

Sherri Lipman McCauley
Lakeway, Texas, USA
https://sherrilipmanmccauley.blogspot.com

*Aging On*
60 × 24 inches | 2014

Maggie Vanderweit
Fergus, Ontario, Canada
http://www.stonethreads.ca

*Room at the Table*
39 × 36 inches | 2016

# Geri Patterson-Kutras

MORGAN HILL, CALIFORNIA

## *Subjects & messages*

I love architecture and landscapes. There's a rich complexity between the two. Each time you add a new element, you create a new relationship. Like actors in a play, each personality shapes and affects the production. More and more of my quilts are based on architecture. I don't see it as static, because it's influenced by how it's used and its age—even the rotation of the earth and the shadows of the sun and moon alter its appearance, shaping a mutable narrative.

While these quilts are a current focus, some of my most powerful pieces are about people and life. Lately, more of my quilts focus on creating smiles. We're living through a very critical period in history. Politics, climate change, the challenges of the connected world—all can become overwhelming. We forget to see the small moments that warm our hearts and make us smile. Against the façade of the big city, there's the little dog that patiently sits on the sidewalk, waiting for a kind stranger to pet it or its human to come home.

## *Stylish images*

I love reading to children and have discovered how wonderful the illustrations in children's books are. Illustrators create images to capture attention and challenge the imagination to see more. My style allows pictures to tell stories through images that draw attention and then engage the viewer with unexpected details. I want my work to give viewers pause to create their own stories.

It's the color, texture, and malleability of our materials that spark my imagination. Sometimes my design comes first, while at other times I find a piece of fabric that informs its place on the design wall.

*Top right:*
*Shelter in Place*
38 × 28.5 inches, 2020

*Bottom right:*
*Morning*
28 × 43 inches, 2020

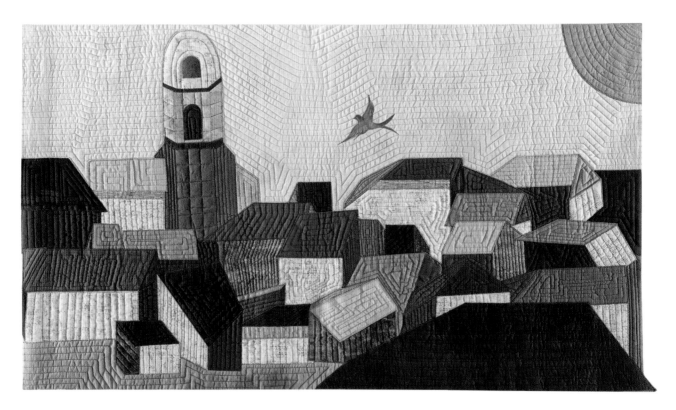

*Roof Tops*
29 × 50 inches, 2020

I've been blessed with a lifelong love affair with creativity. My journey really changed after I retired and I returned to college to complete an art degree. This marked a major shift in the way I approach art. I gained a sense that this is my passion as well as the self-confidence to explore a new path. I am more focused and belong to a community that shares my passion and desire to speak through art.

## Inside the process

Most of my work begins with a photograph. I'm an avid photographer and so are my daughter, Rachael, and my husband, Pete. Our photographs inspire the majority of my work. One of my favorite and most powerful pieces, *Friends*, was inspired by a photo Pete took of two elderly women walking together in Nice, France. I've probably shown and discussed that piece hundreds of times. Regardless of ethnicity or gender, people identify with it. There's something magical about capturing a quiet, unexpected moment and being able to enlarge that moment while maintaining its intimacy.

Using my photograph source, I sketch out a drawing. Once I'm satisfied with the composition, I enlarge it to a workable size at a local print shop. The design is never static; it can and does change as I work with it. One of my favorite parts of the design process is gathering fabrics to articulate my story. The composition is pinned to the design wall so that I can step back periodically and assess its progress.

I use a machine blanket stitch around each cutout shape to secure the jigsaw of pieces together. I like the finished look of the blanket stitch. The work is quilted using a walking foot on my sewing machine. Unexpectedly, I find that I love to write stories or little ditties about my work. As a child I hated writing, but now it's an important component of my work.

I think the most important thing we should understand about ourselves is that we're never too old to follow our creative spirit and try new pathways. Like

*Friends*
62 × 57 inches. 2010

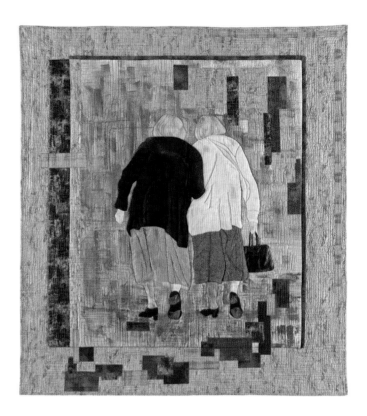

our art, we are a work in progress that needs to be nurtured and developed. I sometimes wish I had recognized this calling much earlier in my life. Then again, some of us find our work is richer because it's informed by our life experiences and desire to tell our stories.

## New projects

This past year has been a challenge. I've enjoyed speaking with guilds and teaching, but it's also been a challenging year with my husband's cancer diagnosis. Feeling overwhelmed caused me to believe that in life we are constantly being challenged. We have the choice of giving into those challenges or reinventing ourselves and moving forward.

The time that I have been in the studio has allowed me to work on three new pieces in my Lines, Angles and Spaces series of neighborhoods and architecture. One of the pieces addresses the challenges we faced about sheltering in place. Another piece is a bird soaring over rooftops, considering the homes and the inhabitants that dwell within their walls.

When my studio time has been limited, I've been doing handwork: it's portable, calming, and creatively satisfying! Using Japanese *sashiko* and *boro* stitching methods with recycled fabric and clothing has been very enjoyable and produced several new pieces. Quilters have an old saying: "When life gives you scraps, make quilts!" My project this year has been to take those scraps that life hands each of us at one time or another, and meet the challenge by finding new pathways for creative expression.

www.geripkartquilts.com

# Musica!

Pablo Picasso said, "To draw, you must close your eyes and sing." This exhibition explores all the wonderful ways in which music can serve as inspiration for the creative process.

Both music and art elicit emotions, create different moods, suggest movement, and can reflect light, depth, and color. Over time, many artistic practices and processes have been shaped by sound and visual expression. The boundaries between music and art blur, as one becomes inspiration for the other.

Pat Kroth
Verona, Wisconsin, USA
https://krothfiberart.com/home.html

*Back Beat*
41 × 31 inches | 2019

Deborah Kuster
Conway, Arkansas, USA https://
www.deborahkuster.com

*Gladness*
16 × 8 × 7 inches | 2019

Sandra Champion
Battery Point, Tasmania, Australia

*a strange and beautiful sound*
37 × 51 inches | 2019
Photo by Bruce Champion

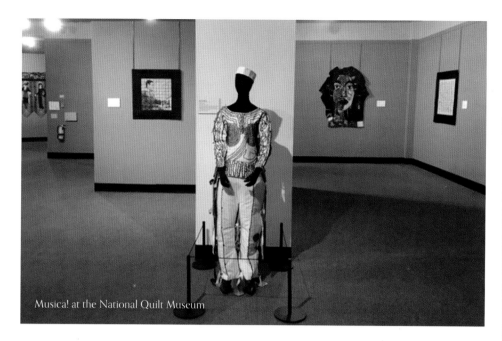

Musica! at the National Quilt Museum

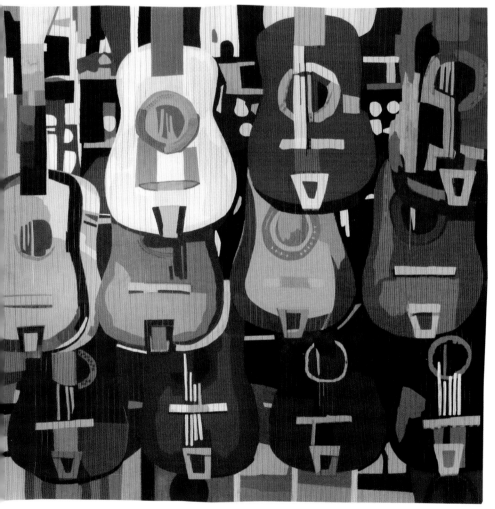

Carolyn Skei
McKinney, Texas, USA
https://www.carolynskei.com

*San Antonio on My Mind*
30 × 30 inches | 2019

Barbara Schneider
Woodstock, Illinois, USA
https://barbaraschneider-artist.
com

*Quiet Moment*
84 × 26 inches | 2015

# Intimate Portraits

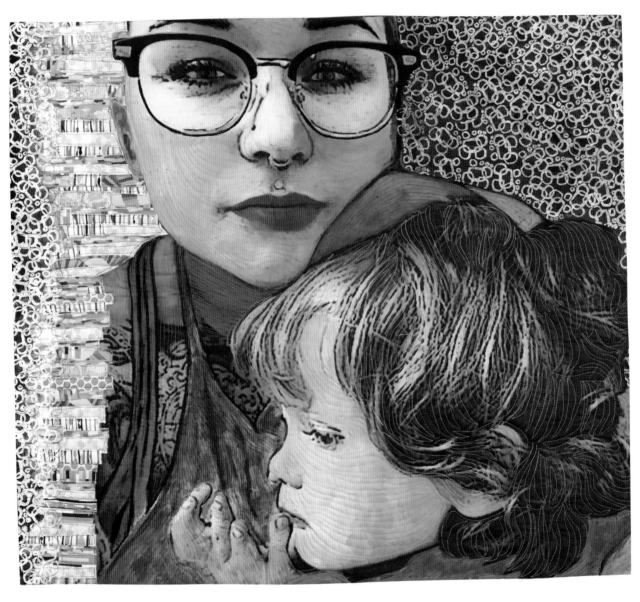

▲ Margaret Lowers Abramshe
St. George, Utah, USA
metaphysicalquilter.com

*Bond*
*32 × 36 inches (81 × 91 cm) | 2019*
*Private collection*

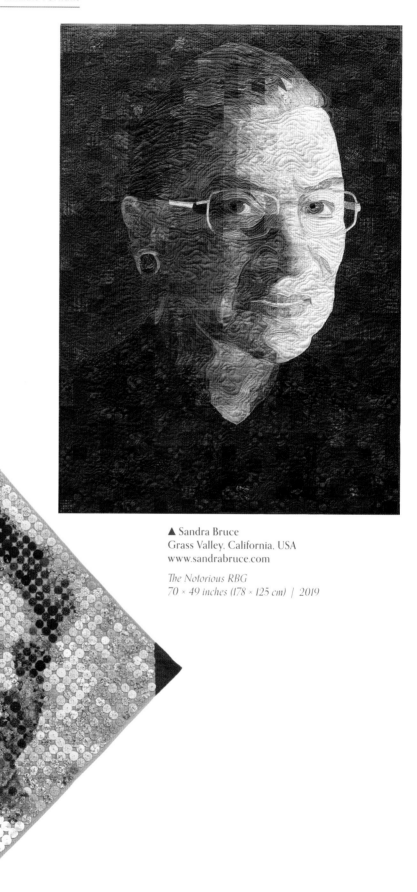

▲ Sandra Bruce
Grass Valley, California, USA
www.sandrabruce.com

*The Notorious RBG*
*70 × 49 inches (178 × 125 cm)  |  2019*

▶ Shin-hee Kang Chin
McPherson, Kansas, USA
www.shinheechin.com

*A Thousand Lives (Ruby Kendrick)*
*63 × 63 inches (160 × 160 cm)  |  2017*
*Photo by Jim Turner*

◀ Jennifer Day
Santa Fe, New Mexico, USA
www.jdaydesign.com

*Long Hard Day*
*32 × 36 inches (81 × 91 cm)  |  2018*
*Private collection*

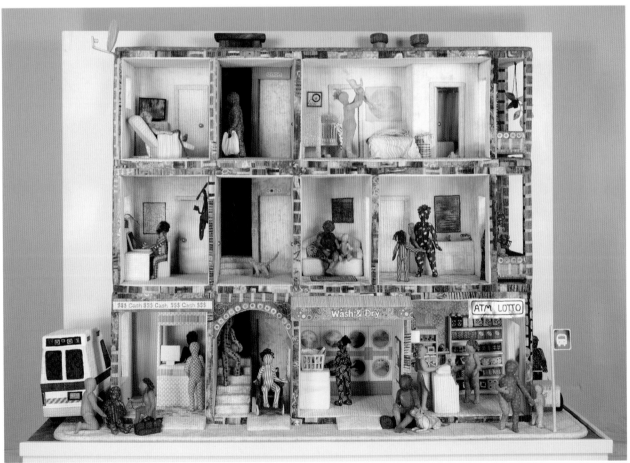

▲ Susan Else
Santa Cruz, California, USA
www.susanelse.com

*We Live Here*
*48 × 65 × 20 inches (122 × 165 × 51 cm)  |  2019*
*Collection of Santa Clara Valley Medical Center  |  Photo by Marty McGillivray*

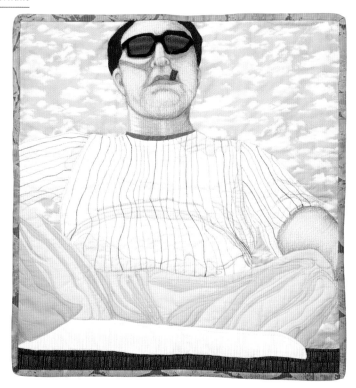

Lora Rocke ▶
Lincoln, Nebraska, USA

*The Big Cheese*
*28 × 27 × 1 inches (71 × 69 × 1 cm)* | *2018*

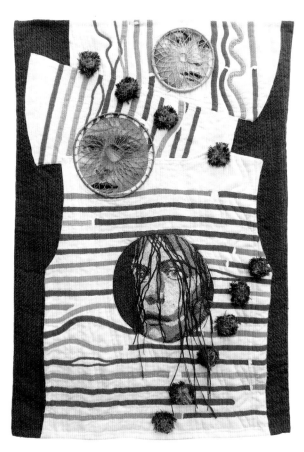

▲ Geneviève Attinger
Pontivy, France
www.attinger-art-textile.odexpo.com

*Le Piège à Demoiselles–Marinière et Pompons Rouges*
*39 × 27 inches (100 × 70 cm)* | *2017*

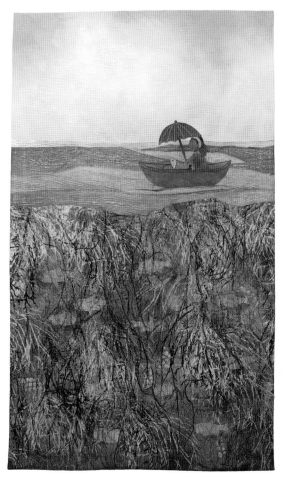

▲ Valerie C. White
Denver, Colorado, USA
valeriecwhite.com

*Catch of the Day*
*50 × 30 inches (127 × 76 cm)* | *2017*

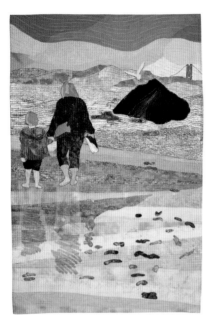

▲ Bev Haring
Longmont, Colorado, USA
www.esmerldas.blogspot.com

*On the Beach*
*29 × 19 inches (74 × 48 cm) | 2019*

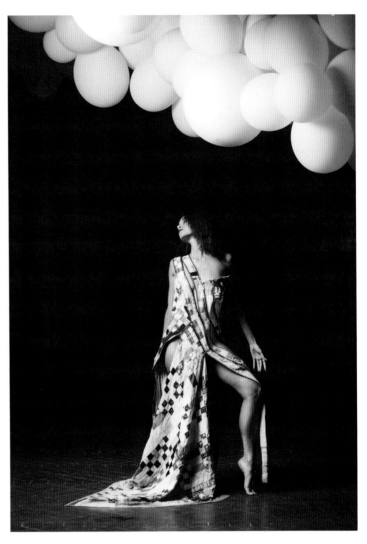

▲ Marty Ornish
La Mesa, California, USA
www.marty-o.com

*Shy Lisbeth Breaks Out of her Shell*
*62 × 27 × 35 inches (158 × 69 × 89 cm) | 2018*
*Photo by Sharon Avraham*

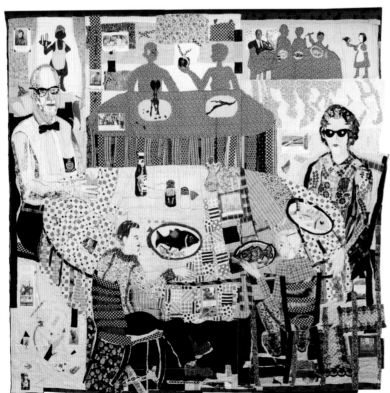

◀ Jim Hay
Takasaki, Gunma, Japan
jim-hay-artist.com

*Fish & Chips*
*98 × 98 inches (249 × 249 cm) | 2017*
*Private collection*

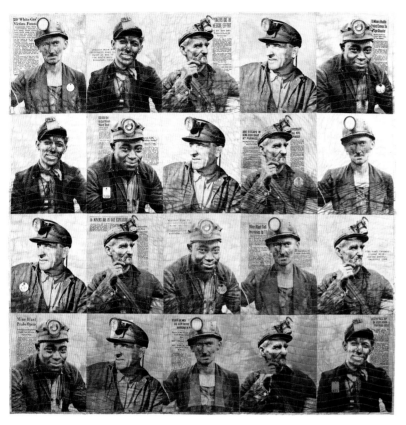

▲ Patricia Kennedy-Zafred
Murrysville, Pennsylvania, USA
www.pattykz.com

*Coal Town: Second Shift*
*60 × 60 inches (152 × 152 cm)  |  2018*
*Photo by Larry Berman*

▲ Sherry Davis Kleinman
Pacific Palisades, California, USA
sherrykleinman.com

*My Friend Winnie*
*50 × 30 inches (127 × 76 cm)  |  2018*
*Private collection  |  Photo by Steven Kleinman*

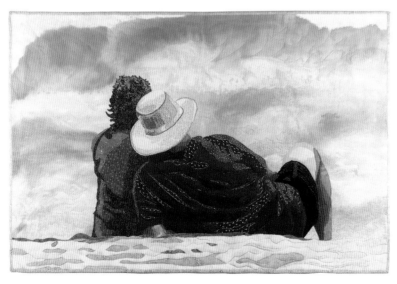

▲ Kathleen McCabe
Coronado, California, USA
www.kathleenmccabecoronado.com

*A Quiet Moment*
*28 × 42 inches (71 × 107 cm)  |  2018*
*Photo by Phil Imming*

▲ Virginia Greaves
Roswell, Georgia, USA
www.virginiagreaves.com

*Kneel Before Me*
*24 × 17 inches (60 × 44 cm)  |  2017*
*Private collection*

▲ Sherri Culver
Portland, Oregon, USA
www.sherriquilts.com

*Equal value, different shades*
*29 × 27 inches (74 × 69 cm) | 2019*
*Photo by Hoddick Photography | Private*
*collection*

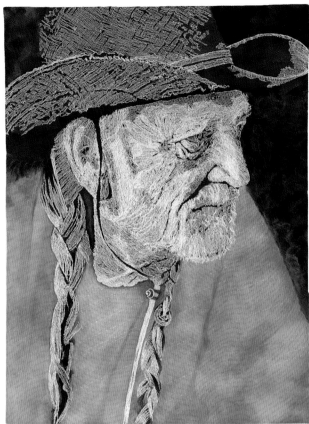

▲ Mary Pal
Toronto, Ontario, Canada
www.marypaldesigns.com

*Willie*
*45 × 34 inches (114 × 86 cm) | 2018*
*Photo by Thomas Blanchard*

▲ Maggie Dillon
Sarasota, Florida, USA
www.maggiedillondesigns.com

*Missed Trains*
*52 × 42 inches (132 × 107 cm) | 2018*

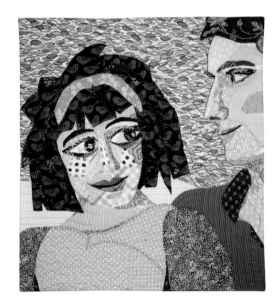

▲ Karol Kusmaul
Inverness, Florida, USA
www.kquilt.com

*Flirting*
*28 × 26 inches (71 × 66 cm) | 2018*

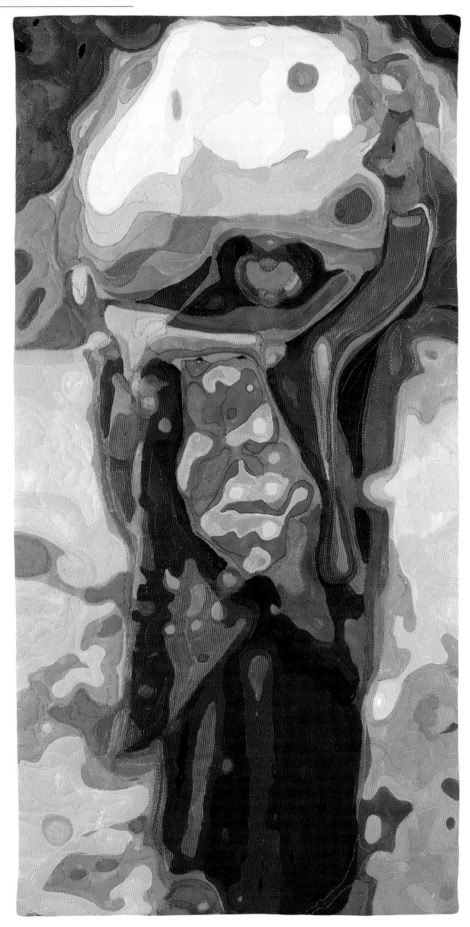

▶ Kathleen Kastles
Wailuku, Hawaii, USA
www.kathleenkastles.com

*Bundle*
*28 × 14 inches (71 × 36 cm) | 2019*
*Photo by Xinia Productions*

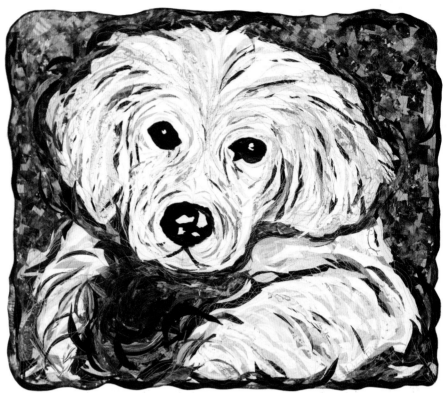

▶ Deborah Fell
Urbana, Illinois, USA
www.deborahfell.com

*Puppy Love: Zane*
*48 × 49 inches (122 × 125 cm)  |  2018*
*Private collection*

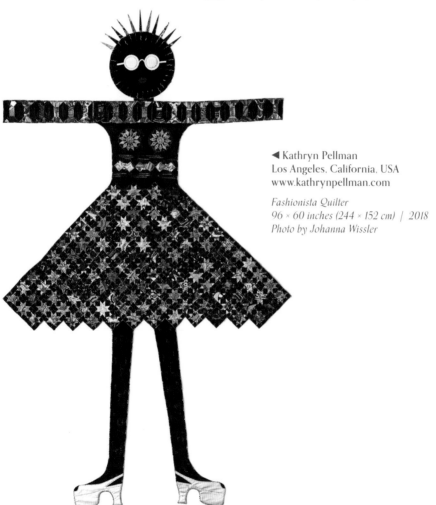

◀ Kathryn Pellman
Los Angeles, California, USA
www.kathrynpellman.com

*Fashionista Quilter*
*96 × 60 inches (244 × 152 cm)  |  2018*
*Photo by Johanna Wissler*

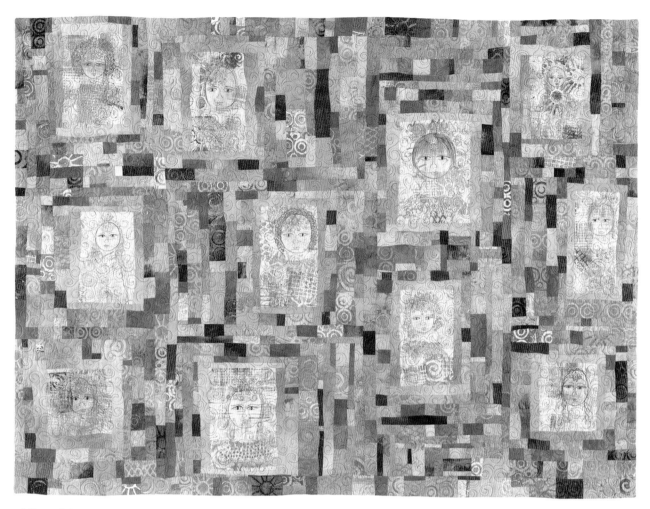

▲ Susan Schrott
New York, New York, USA
www.susanschrottartist.com

*Sisters of My Soul*
*48 × 64 inches (122 × 163 cm) | 2018*
*Photo by Christopher Burke*

# Kathryn Pellman

LOS ANGELES, CALIFORNIA

## *Falling for quilts*

My background is in fashion design, and I wanted to combine my love of fashion with traditional quilting elements. I first saw art quilts in person at *The Art Quilt* exhibition in 1986 and was inspired to make my first piece a year later.

I explore women and femininity. My favorite theme is joyful, happy, playful, and fun fashionistas. They combine my love of fashion, romance, domesticity, gardening, cooking, and storytelling with excessive detail and humor. I want to create playfully whimsical pieces that entertain the viewer and me. As for all the small dogs in my quilts, I used to be a cat person until I fell for Liza, a 13-pound deer Chihuahua who passed away recently. I've now adopted Petunia Olive, a miniature dachshund, and discovered that I have a lot of dog fabric.

My latest series, Angry Woman, explores my feelings about female empowerment and feminism, and my concerns about current events and social issues. These issues include free speech, gun control, homelessness, and same-sex marriage.

My key messages find avenues in which to appear in all of my series. I often try to start a piece with a destination in mind, but I don't always know where I'm going until I get there. The entire story can change based on an image I find in fabric, a random phrase I hear, or how words I cut from fabric fall onto my work surface. Only my quilts that explore current events and social issues have a deliberate message.

*A Fashionista In Quarantine*
24 × 24 inches, 2020
*Photo by Johanna Love*

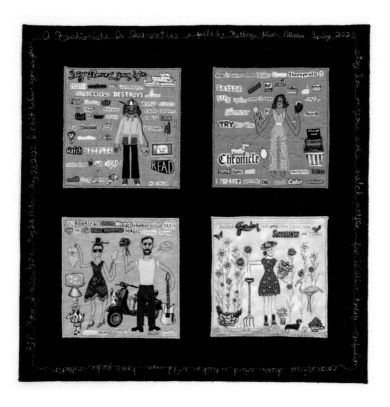

## Series work

I don't think my series will ever end, although sometimes they take a lengthy break. My Angry Woman series is starting to focus more on the shape of the piece and less on social statement. My Word Salad series, which combines found poems and fashionistas, has provided a break from my larger pieces and allows me to play with small details. These quilts will become part of a book I plan to publish: *Word Salad, Girlfriends and Fashionistas.*

When I need to regroup, I like to play with a series I call Not So Mindless Scrap Quilts, which uses traditional quilt blocks and busy prints. The geometric blocks remind me of what first attracted me to quilts. I revisited this series for inspiration when I made *Fashionista Quilter (see page 136)*, which uses many different quilt patterns; her varied look has an Ohio Star skirt with a bowtie waistband, sunflower breasts, and spool arms.

Although Word Salad is a relatively new series that brings together fashionistas and found poems, I have placed words into my quilts for a long time. Early on, I used song lyrics, but I really wanted to use my own words. I was introduced to found poems in a writing class. I enjoy the freedom I have working with the smaller scale of this series.

*Left:*
*The Beauty Shop*
8 × 8 inches. 2019

*Right:*
*Cowboy Jack and Geeky Chic
Lulu*
8 × 8 inches. 2019

## Starting a piece

My art is a personal reflection of me and everything I think about, am interested in, and believe in. And, much like I manage my life, most of my pieces are planned in my head with a rough sketch and not completely formed when I start a new piece. So, midway through construction, things can appear scrambled and chaotic even though they are not. Although I have a vision when I start, it is sometimes more of an idea, and I have to wait for the piece to evolve as I figure out the details, especially construction, as I go along.

Sometimes I get stuck somewhere in the middle and can't figure out how to move forward. When that happens, I step away for a few hours and either take a walk, get a latte, or go to my local fabric store and buy something that I almost never use in the piece. If it's late in the evening, I go to sleep. Always, when I return to my studio the next day, the solution is right there in front of me.

## Setting a style

I'm influenced by fashion design, folk art, and traditional quilting as well as the art of Sonia Delaunay and Maira Kalman. I always knew what I wanted my quilts to look like, even before I had the skills to execute them. As my technical and design skills improved, I developed a distinctive style. The first time I applied to be a SAQA juried artist, I was rejected. After due consideration, I realized that my quilts needed to connect to each other, and that not every piece had to be completely different. This was a freeing outlook.

My work evolved as I adopted the use of several techniques: raw-edge fusible appliqué, buttonhole stitching in place of traditional bindings, and the addition of extra layers and medium-weight stabilizer to provide body for free-form pieces. My fascination with printed fabric and traditional quilt blocks remains strong and continues to influence everything I create.

*Left:*
*Without A Home*
88 × 57 inches, 2018

*Right:*
*End Gun Violence*
58 × 39 inches, 2017

## Work rewarded

Recently, two pieces that were accepted into a SAQA Global Exhibition also were selected for publication. In addition, my photographer works for a quilt publication and was looking for a piece to fit a theme that matched my style. I met Susan Brubaker Knapp, the host of *Quilting Arts TV*, when she spoke at my quilt guild. I spent the afternoon showing her around downtown Los Angeles, which led to an invitation to be on the show. I submit images to SAQA publications and to the Visions Art Museum's online themed exhibitions.

## Lasting impression

I love fabric, fashion, sewing, and storytelling, and I am so happy when I get to spend days in my studio combining them and creating new pieces. It's always a surprise, and I never know what the finished piece is going to look like.

# Opposites Attract

Opposing forces shape our reality in ways that are both readily apparent as well as hidden. Artwork included in this exhibit explores contradictions and affinities: yin and yang, black and white, the irresist- ible force versus the immovable object.

Monique Gilbert

*Samurai with Tsuba*
58 × 29 inches | 2019
Photo by Studio Leeman Leuven

Bobbi Baugh
https://www.bobbibaughstudio.com

*Rust Happens*
43 × 59 inches| 2019

Niraja Lorenz
https://www.nirajalorenz.com

*Black Hole*
37 × 37 inches | 2019

Shin-hee Chin
https://shinheechin.com

*Half Full, Half Empty*
40.5 × 29 inches | 2019

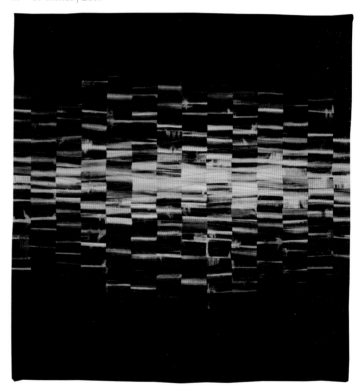

Eunhee Lee
https://blog.naver.com/dream2005

*Coexiestence of Light and Darkness*
36.5 × 34.5 inches | 2019

Caryl Bryer Fallert-Gentry
http://www.bryerpatch.com

*Jacuzzi Jazz #1*
60 × 60 inches | 2015

# Ulva Ugerup

MALMÖ, SWEDEN

## *Art quilt awakening*

I have been sewing and drawing for as long as I can remember. I used my mother's electric sewing machine when I was old enough to carry it out from the wardrobe and put it on a table.

I don't try to find ideas; inspiration finds me. My muse often arrives whenever I try to make nonfigurative quilts. I hardly ever succeed. My quilt *The Nine Muses* was planned and pieced as an ordinary log cabin quilt, its blocks set in three horizontal and three vertical rows. Unexpectedly, late one evening there was a noise and loud voices at my creative front door. I opened the door to find nine upset little ladies, demanding their places in my quilt! What could I do? Since then, I often have animated discussions with my ladies about important things like hats and dresses, and whether or not to dance. The Irish performance group River Dance has great symbolic value for me.

Experiences, memories, materials, and colors inspire me. *Hallelujah Ladies No. 5* depicts a clear childhood memory of relatives coming to visit us. I remember my Aunt Ida's fantastic hat and the grown-up conversation, although I didn't understand it at the time. It was about illicit home burning [making moonshine] in the southeastern part of Sweden.

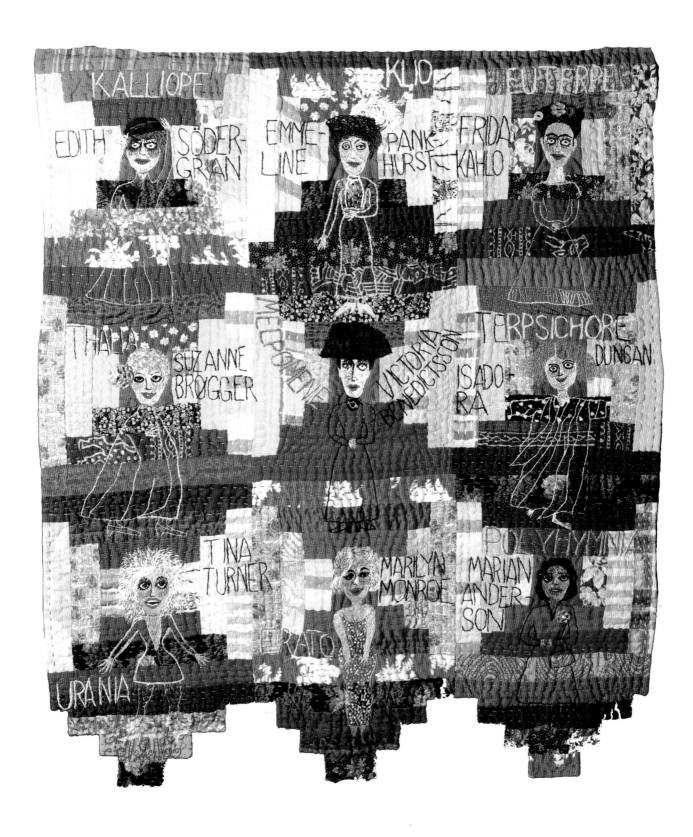

*The Nine Muses*
34 × 30 inches, 2006

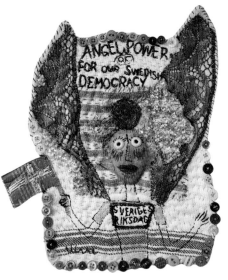

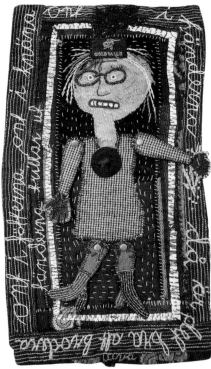

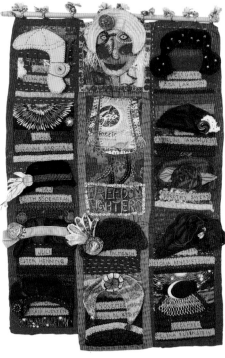

## Stories in cloth

Through my quilts, I want to express what I feel about women's history, women's liberation, suffragists, and famous women–from Marie Curie, who researched radiation, to Mary Anderson, who invented the windshield wiper.

As I age, my quilts also chronicle my walking difficulties, shaky hands, and fear of falling, as can be seen in *Pain in Hands, Knees, Back and Teeth–then Embroidery Helps!* We also have a growing problem in Sweden with violence against old people. I have experienced strangers forcing themselves into my home to try to rob me. They disappeared when my loud screams scared them away. I am never out alone after dark; in the daytime I walk on streets with lots of traffic and people. My feelings about this situation are expressed in small quilts about my home, property, and anger.

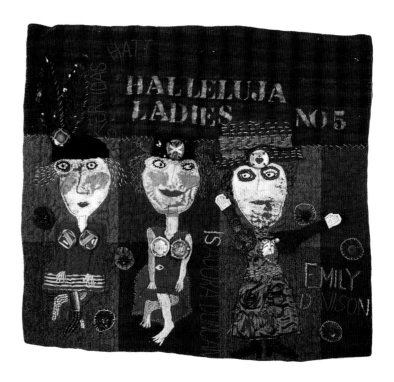

*Halleluja - Ladies No. 5*
17 × 19 inches, 2016

## Artistic process

I work in a "naive" style. Early on, I made more realistic portraits, but today they're more symbolic. Through faces, I express joy, anger, and determination. The faces also play into my value perspective, since they are often large and out of proportion with the rest of the subject.

My creative process is very simple: I usually start at the top left corner and work to the right and down. I never make sketches. I seldom sew a whole picture in one session. I make and quilt each piece, then I sew the pieces together, embroider, and add embellishments. Sometimes I add new pieces, already quilted and embroidered, to finished quilts.

My materials can be a starting point, as was the tin can used to dress the central lady in *Freedom Fighters*. The hat in the quilt *Birthright of Women* was originally a shoe buckle.

Other elements can play key roles too. Sometimes I make arms and legs movable, using bag clips. The British suffragist Emily Davison pictured in the quilt *Hallelujah Ladies No. 5* holds out her arms to try to stop a racehorse.

I live in a world of scraps, ribbons, buttons, pearls, sequins, embroidery floss, and ornaments. My daughter Wanda supplies me with goods from flea markets. All the worn-out linen towels I inherited from my mother and grandmother impart a history. My *Angel of Power* has wings made from sequins bought fifty-five years ago at the Porte de Clignancourt flea market in Paris, and pieces from a golden shawl given to me by a Danish friend who made dresses for members of the Danish royal family.

# Fibreworks: Art Quilts in South Africa

BY JEANETTE GILKS

Fibreworks members are humorously described today as "Ex-centrics" by member Celia de Villiers because the South African art group, founded in 1998, has moved from the traditional tenets of most quilt groups to the outer edges. Here some of the members talk about their love affair with textiles.

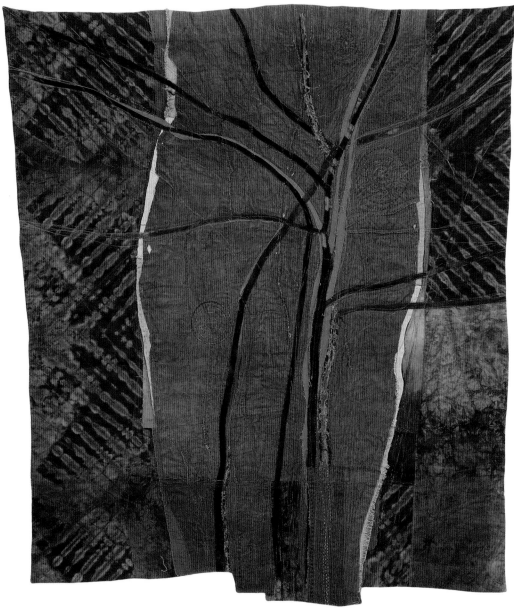

Rosalie Dace
*Diaspora*

45 × 38 inches, 2015
*Photo by Diane Herbort*

Fibrearts member Rosalie Dace says, "Sometimes my pieces are made by machine and sometimes by hand, but generally both. They might be functional quilts or garments, or most times abstract explorations of color, line, and texture." These simple sentences cover the entire history of textiles from its ancient hand-crafted and functional past to the contemporary idea that textile art can be a manipulation of the elements of design, using cloth as a medium. She says, "Textiles fascinate me. The tactile quality and human history of cloth allow me to be part of an age-old tradition of folding, stitching, and feeling cloth."

Abstract surface design is also typical of the work of Odette Tolksdorf: "Several ideas converge in one work, and I inhale influences from many sources. I usually work in a direct, improvisational approach." This intuitive, holistic way of working characterizes the way Jenny Hearn works too. It's an "all-at-once" way of seeing, when the artwork itself is the guide, with the artist merely following. She says, "I never know where a piece of work in going till I get there, and manipulating the fabric is demanding and difficult. I'm not always in control. But when the work becomes whole, that is the magic and the peace."

Jenny Hearn
*Wyeast (Volcano IV)*

74 × 74 inches. 2012
*Photo by Dion Cuyler*

Odette Tolksdorf
*Pentimento*

29 × 19 inches, 2008
*Photo by Christopher Baker*

Kathryn Harmer Fox
*The Tattoo Artist*

53 × 32 inches, 2019

Many artists rework textiles that have previously been used for other purposes. Tolksdorf's *Pentimento* contains material from a vintage Australian woolen blanket and mulberry bark cloth from Tonga. The original life of the found material continues on in the new artwork. The wool remembers the old sheep, and the bark cloth remembers its tree. There seems to be a yearning of all things to be in some kind of relationship with other things. *Pentimento*, an art-historical term that refers to the presence of earlier marks made by an artist during the drawing or painting process, illustrates a desire to resurrect relationships between painting and stitching.

Kathy Harmer Fox creates crossovers between painting and embroidery. She says, "My art quilts are informed by my ability to draw, and my paintings have been enlivened by my ability to stitch. One genre feeds the other, increasing the visual value of each." She begins by layering cut pieces of dress material, pinning each snippet of fabric to the canvas base. "Some are faded with wear, while others are

Annette McMaster
*A Tribute to Desmond and Leah Tutu*

30 × 30 inches, 2016
*Photo by Ockert Kruger*

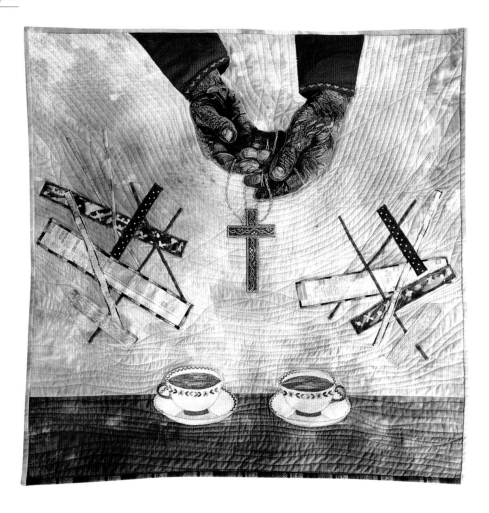

garish, but once they are stitched, they become an eye or a tattoo."

Annette McMaster quotes Louise Bourgeois: "I am not what I am; I am what I do with my hands." McMaster suggests we become who we are through the actions of our hands, and that becoming who we are is a lifelong, practical journey. "Our work is never perfect, but a stimulus for the next creation, be it through drawing, painting, or collage."

Sally Scott uses fabric to tell stories. Raised in the bushveld of Zimbabwe and Botswana, her works are a form of visual journaling. She says, "They become a kind of incomplete autobiography, weaving together my life experiences, my passion for Africa, its people, and its landscape." Although *The Nurturer* is a symbolic skirt displayed on a wall, the history and function of cloth as a means of body covering is layered into the content of the work. Other skirts in this series represent aspects of the natural life cycle and express the idea that human beings are

an integral part of nature. She says, "I love the feel of fabric, soaked in its saturated color, rich in its various textures and characteristics. It is seductive and expressive." This in-the-flesh relationship that quilt artists have with their work is transferred to the viewer. They want to touch the work, and they often ignore the "hands off" signs at exhibitions, peering behind an art quilt or furtively bringing the corner of it to their cheek. Textile art illicits a powerful sense of touch.

For Celia de Villiers, the conceptual underpinning of the work is essential. "The art quilt should be more than merely pleasurable, beautiful, or decorative." She makes deliberate use of repurposed postconsumer materials to comment critically on the environmental and biological effects of sea pollution. She asks, "How can technical manipulation of the medium reflect and transmit the contemporary creative involvement of the artist? Medium and concept are inseparable in my artworks. As my

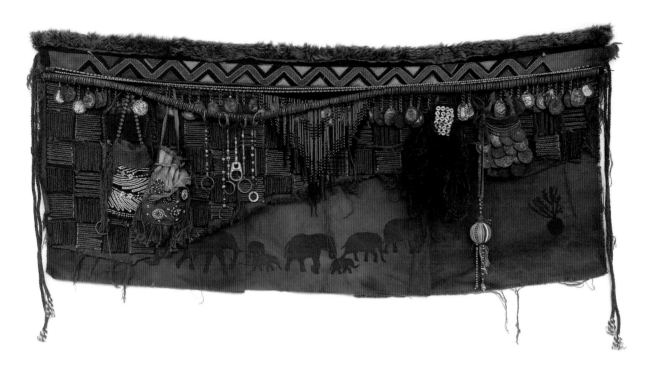

Sally Scott
*The Nurturer*

20 × 40 inches, 2018
*Collection Lalibela Game Reserve*

*Opposite page:*

Celia de Villiers
*Litany*

78 × 118 inches, 2015

thinking and creative processes are essentially sculptural, I attempt to bend, and go beyond, the rules of traditional quilting and use textiles in a three-dimensional manner."

The artworks here are transparent. We can look at them, and then with further looking, we look through them. They comment on the ongoing discussions concerning "women's work" and the evolving nature of these ancient craft practices in contemporary quilt art.

*Jeanette Gilks has been making, teaching, and assessing art for about forty years while teaching in secondary and tertiary institutions. In 1988 she founded Garret Artists, a drawing workshop for students and teachers, and in 1998 she cofounded Fibreworks. This group has exhibited in South Africa and abroad. She currently teaches creative thinking skills and drawing to students at Vega, a tertiary college in Durban specializing in branding. Some of her work can be found on Instagram: @jeanettegilks.*

fibreworksart.com

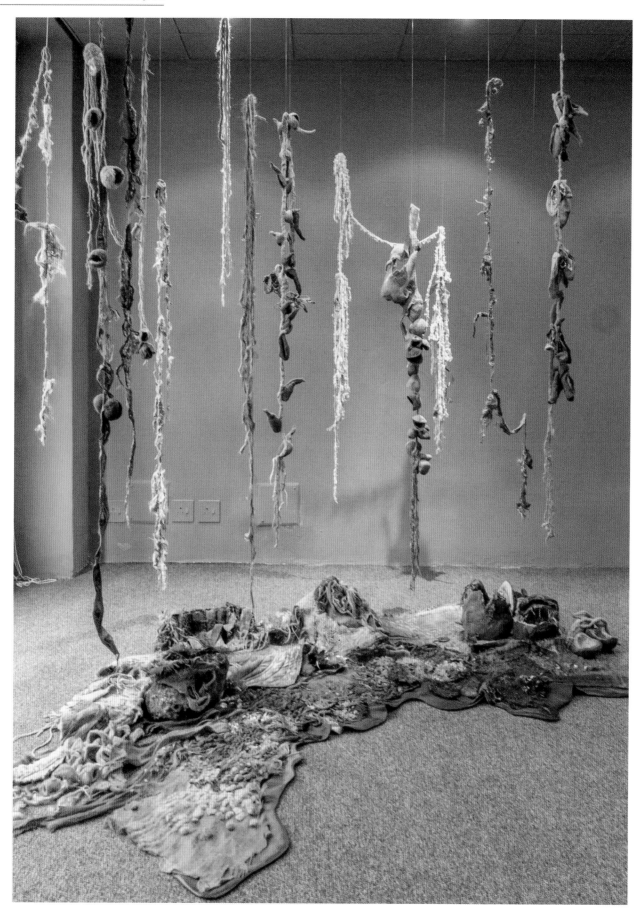

Beth and Trevor Reid
Gowrie, ACT, Australia
*Moody Blues*
46.5 × 27 inches | 2019
Photo by Trevor Reid

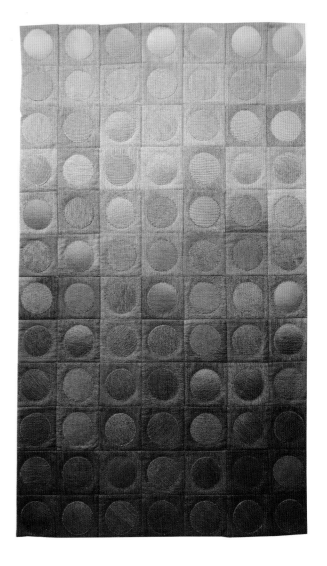

# Upcycle!

Fiber art has a rich tradition of incorporating elements that would otherwise be discarded by turning them into compelling compositions. Repurposing materials is one of the most effective solutions to deal with today's environmentally devastating waste issues. Full of creative energy, *Upcycle!* offers artwork with intriguing details and unusual materials and will surely spark conversations from viewers.

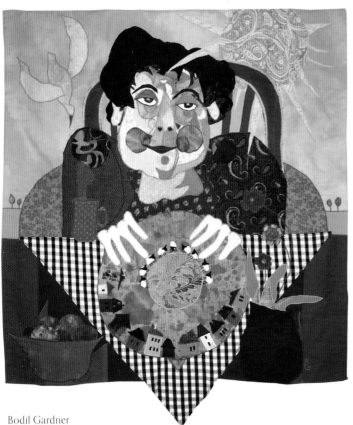

Bodil Gardner
Lystrup, Denmark
http://www.bodilgardner.dk

*Mother Earth*
45 × 40 inches | 2018
Photo by Peter Gardner

Laura Wasilowski
Elgin, Illinois, USA
http://www.artfabrik.com

*Painting the Town #1*
47 × 33 inches | 2014

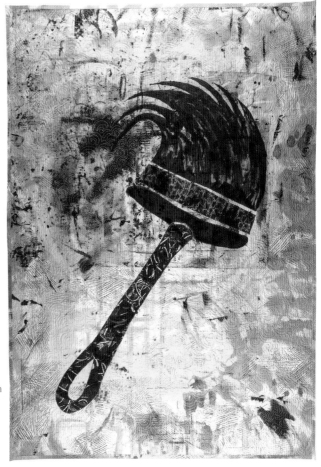

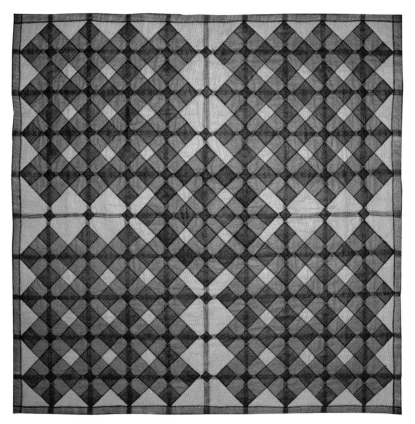

Sherry Davis Kleinman
Pacific Palisades, California, USA
https://www.sherrykleinman.com

*Barn Quilt Screen Style*
43 × 43 inches | 2018  Photo by Steve Kleinman

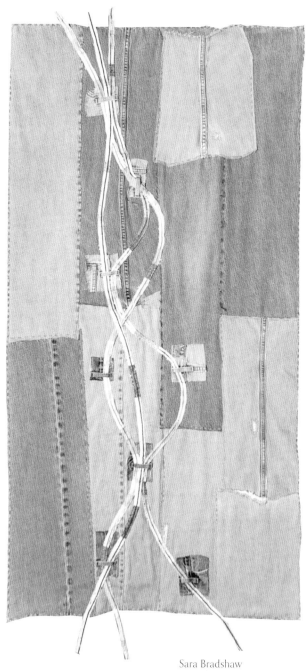

Sara Bradshaw
Spencer, Tennessee, USA

*Ties That Bind*
61 × 32 inches | 2018
Photo by Brandon Malone

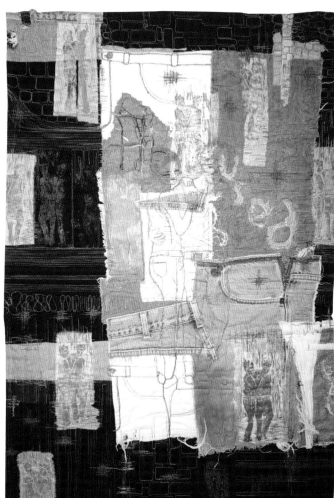

Heidi Drahota
Nuernberg, Bavarian, Germany
https://www.heidi-drahota.de

*The Beautiful Appearance*
39 × 27 inches | 2017

# Forced to Flee

Throughout history people have been forced to flee from their homes for their own safety and survival due to war, oppression, natural disasters, and human rights violations.

This exhibition explores the issues surrounding the global refugee crises, impacts on families and communities, the stress placed on host countries, and the need for new initiatives, funding, and international cooperation to find solutions.

Charlotte Bird
San Diego, California, USA
www.birdworks-fiberarts.com

*Goodbye My Village*
48 × 32 inches | 2018
Photo by Gary Conaughton

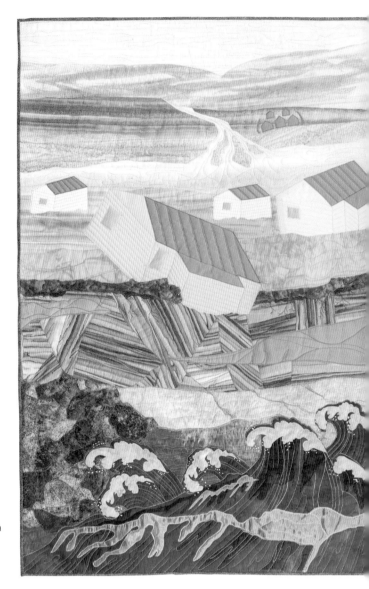

Forced to Flee at the Ruth Funk Center for Textile Arts
Photo Blueprint Productions

Jennifer Day
Santa Fe, New Mexico, USA
https://jdaydesign.com

*Tengo Hambre—I am Hungry*
38 × 43 inches | 2016

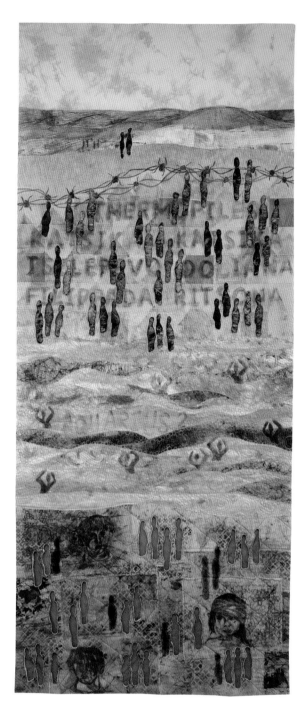

Claire Passmore
Plymouth, Devon, UK
https://www.clairepassmore.com

*The Lucky Ones?*
69.5 × 29 inches | 2018

Sabi Westoby
London, Middlesex, UK
http://www.sabiwestoby.com

*Page 27 - Exodus I*
44 × 37 inches | 2018
Photo by Benjamin Westoby

# Surface Design

▲ Nancy Bardach
Berkeley, California, USA
www.nancybardach.com

*Bolt From the Blue*
*44 × 62 inches (112 × 158 cm)  |  2018*

▶ Linda Colsh
Middletown, Maryland, USA
www.lindacolsh.com

*Water Writing*
*40 × 40 inches (102 × 102 cm) | 2017*
*Photo by Ryan Stein Photography*

▲ Judith Content
Palo Alto, California, USA
www.judithcontent.com

*Meltwater*
*55 × 40 inches (140 × 102 cm) | 2017*
*Photo by James Dewrance*

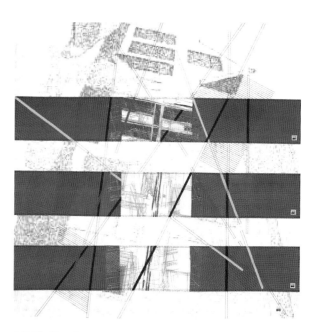

▲ Willy Doreleijers
Dordrecht, Zuid Holland, Netherlands
www.willydoreleijers.nl

*Blue Print*
*41 × 41 inches (106 × 104 cm) | 2017*
*Photo by Herman Lengton*

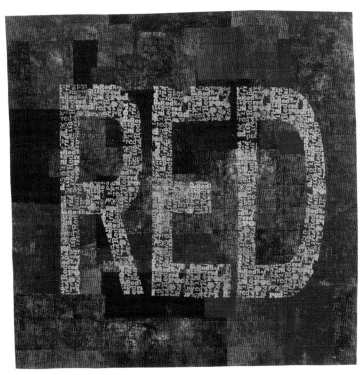

◄ Catherine Kleeman
Ruxton, Maryland, USA
www.cathyquilts.com

*Seeing Red*
*44 × 44 inches (112 × 112 cm)  |  2018*

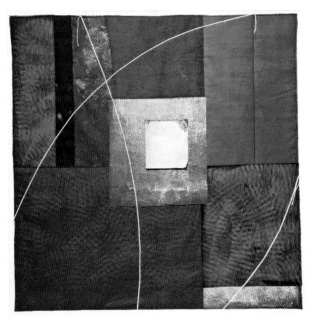

▲ Katriina Flensburg
Storvreta (Uppsala), Sweden
www.katriinaflensburg.se

*At Crossroads #4*
*36 × 36 inches (91 × 93 cm)  |  2018*
*Private collection*

◄ Judy Hooworth
Morisset, New South Wales, Australia

*Chinese Whispers*
*49 × 64 inches (126 × 164 cm)  |  2017*
*Private collection*

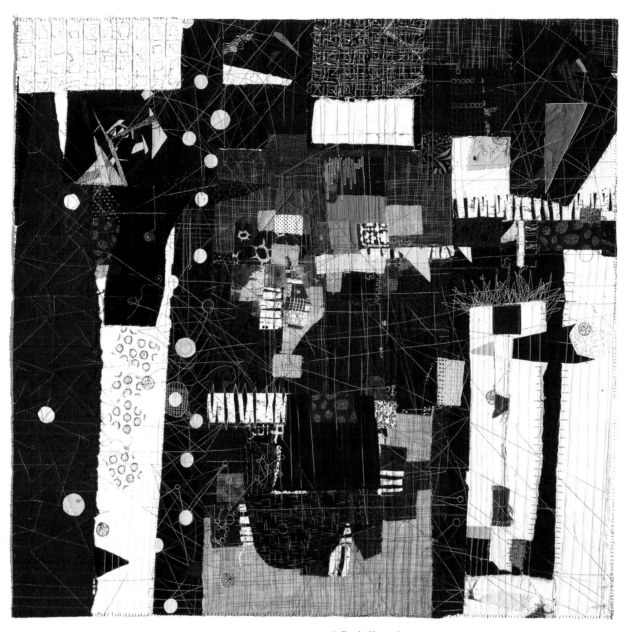

▲ Paula Kovarik
Memphis, Tennessee, USA
paulakovarik.com

*Beastie Boy and His Pals*
*40 × 41 inches (100 × 104 cm) | 2018*
*Photo by Allen Mims*

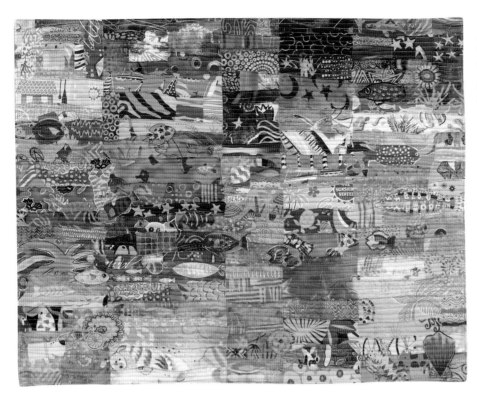

◄ Susan Rienzo
Vero Beach, Florida, USA
www.susanrienzodesigns.com

*Gone Fishing*
*24 × 30 × 2 inches (61 × 76 × 4 cm)* | *2018*

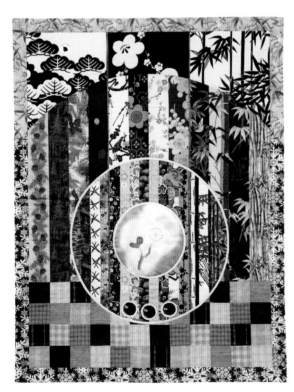

▲ Teresa Barkley
Maplewood, New Jersey, USA

*Three Friends of Winter*
*51 × 39 inches (130 × 99 cm)* | *2017*
*Photo by Jean Vong*

◄ Julia E. Pfaff
Richmond, Virginia,
USA
www.juliapfaffquilt.
blogspot.com

*Repeat V*
*68 × 35 inches*
*(172 × 88 cm)* | *2017*
*Photo by Taylor Dabney*

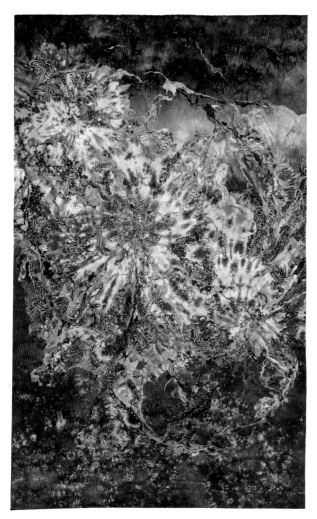

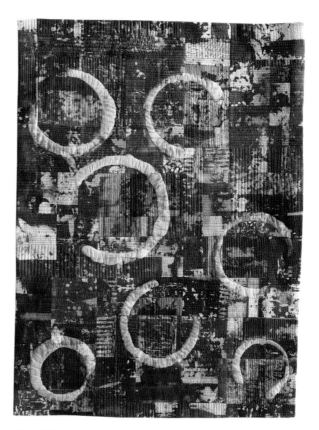

▲ Lisa Walton
Sydney, New South Wales, Australia
www.lisawaltonartist.com

*Broken Circles*
*40 × 30 inches (102 × 76 cm) | 2019*
*Photo by Margot Wlkstrom*

▲ Grace Harbin Wever
Union Grove, Alabama, USA
www.weverart.net

*The Sixth Seal III*
*65 × 40 inches (165 × 102 cm) | 2019*
*Photo by Jeff White Photography*

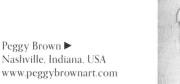

Peggy Brown ▶
Nashville, Indiana, USA
www.peggybrownart.com

*Pages in My Book*
*35 × 65 inches (89 × 165 cm)*
*2017*
*Collection of William and Maureen Koza*

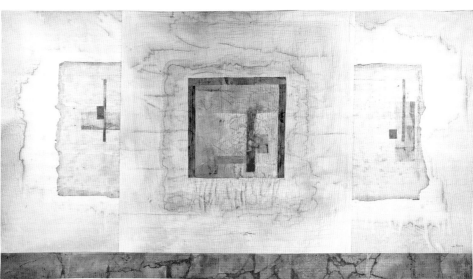

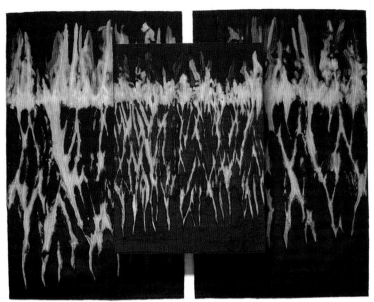

◄ Regina V. Benson
Golden, Colorado, USA
www.reginabenson.com

*Night Fire*
*36 × 47 × 4 inches (91 × 119 × 10 cm)  |  2019*
*Photo by John Bonath*

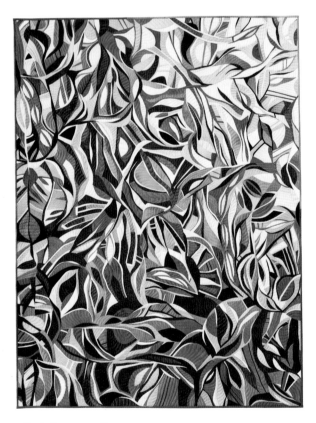

▲ Sheila Frampton-Cooper
Martigues, Bouches-du-Rhône, France
www.zoombaby.com

*Crystal Mer*
*43 × 33 inches (84 × 109 cm)  |  2018*

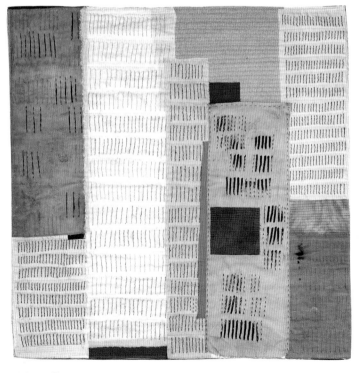

▲ Jette Clover
Antwerpen, Belgium
www.jetteclover.com

*Significant Stitches*
*40 × 40 inches (102 × 102 cm)  |  2017*
*Photo by Pol Leemans*

▲ Kay Liggett
Monument, Colorado, USA
ridgewaystudios.org

*Pompei and Vesuvius, AD 79*
*27 × 24 inches (69 × 61 cm)* | *2018*

▲ Alicia Merrett
Wells, Somerset, UK
www.aliciamerrett.co.uk

*Blue Remembered Hills*
*35 × 28 inches (89 × 71 cm)* | *2018*
*Collection of Martin Fletcher*

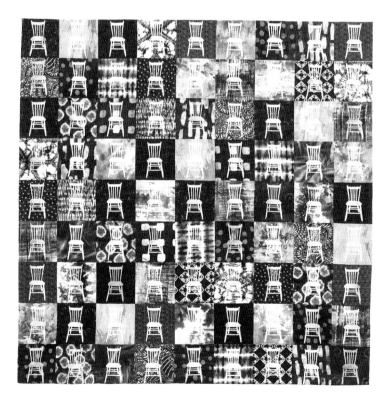

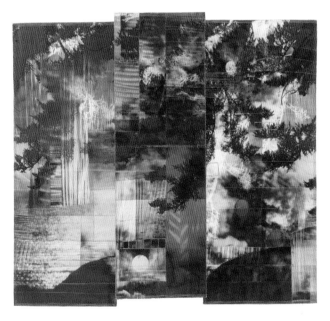

▲ Maggie Vanderweit
Fergus, Ontario, Canada
www.stonetheads.ca

*Indigo Party*
*53 × 53 inches (135 × 135 cm)* | *2019*

▲ Charlotte Ziebarth
Boulder, Colorado, USA
www.charlotteziebarth.com

*How Many Moons?*
*36 × 39 inches (91 × 99 cm)* | *2018*
*Photo by Ken Sanville*

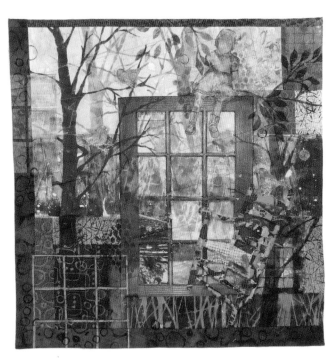

▲ Bobbi Baugh
DeLand, Florida, USA
www.bobbibaughstudio.com

*Look Through to the Memory*
*42 × 42 inches (107 × 107 cm) | 2019*

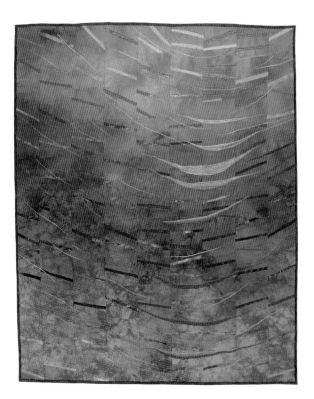

▲ Joke Buursma
Portlaw, Waterford, Ireland
www.jokebuursma.weebly.com

*Gaelforce*
*44 × 35 inches (113 × 90 cm) | 2019*

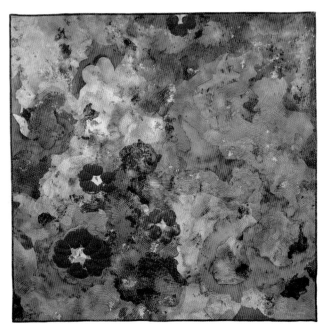

▲ Erika Carter
Renton, Washington, USA

*Je Ne Sais Quoi*
*42 × 44 inches (107 × 111 cm) | 2018*

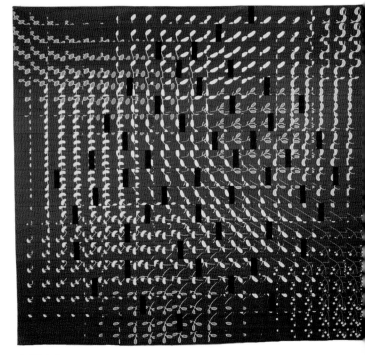

▲ Jill Ault
Ann Arbor, Michigan, USA
www.jillault.com

*Interrupted*
*55 × 61 inches (140 × 155 cm) | 2017*

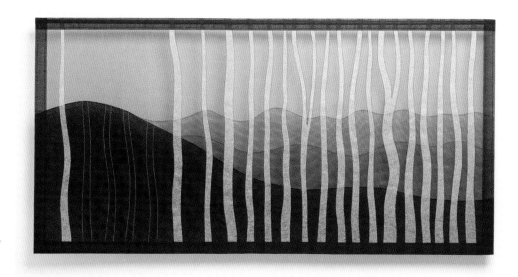

Dianne Firth ▶
Canberra, ACT, Australia

*Black Mountain #3*
*27 × 54 inches (69 × 137 cm) | 2017*
*Private collection | Photo by*
*Andrew Sikorski*

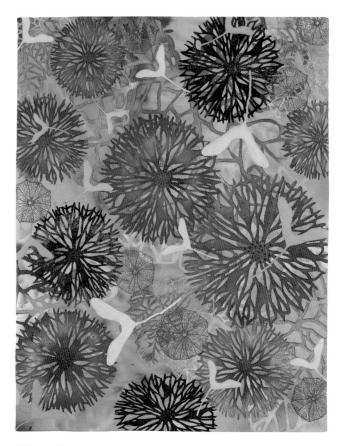

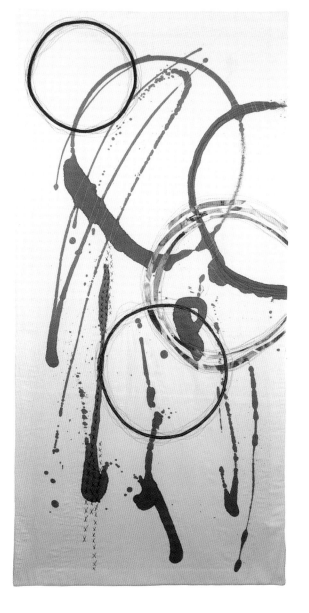

▲ Sandy Gregg
Cambridge, Massachusetts, USA
www.sandygregg.com

*Spring Bloom*
*43 × 34 inches (109 × 86 cm) | 2018*
*Photo by Joe Ofria*

Sherri Lipman McCauley ▶
Lakeway, Texas, USA
www.sherrilipmanmccauley.blogspot.com

*Touch of Color*
*44 × 22 inches (112 × 56 cm) | 2018*

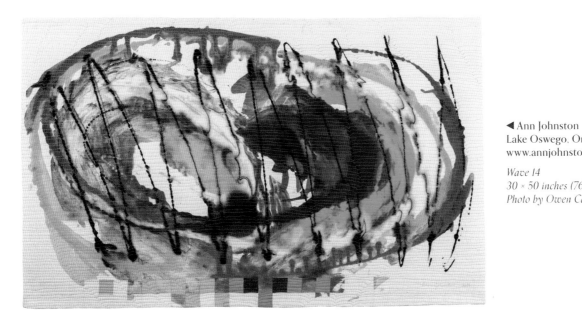

◄ Ann Johnston
Lake Oswego, Oregon, USA
www.annjohnston.net

*Wave 14*
*30 × 50 inches (76 × 127 cm) | 2017*
*Photo by Owen Carey*

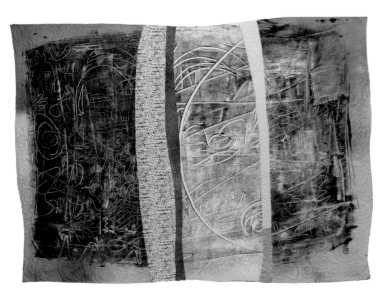

◄ Regina Marzlin
Antigonish, Nova Scotia, Canada
www.reginamarzlin.com

*The Soul of the Night*
*30 × 40 inches (76 × 102 cm) | 2018*

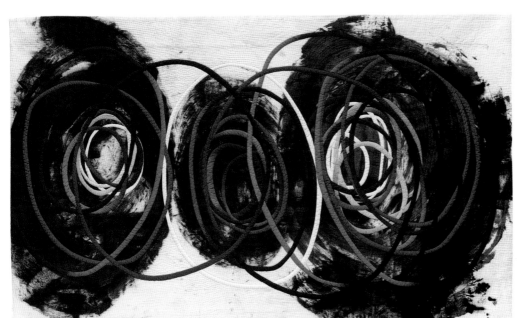

◄ Judy F. Kirpich
Takoma Park, Maryland, USA
www.judykirpich.com

*Memory Loss No. 1*
*47 × 80 inches (119 × 203 cm) | 2018*
*Photo by Mark Gulezian*

▲ Sue Dennis
Brisbane, Queensland, Australia
www.suedennis.com

*il Vaso con Fiori*
*39 × 33 inches (98 × 84 cm)  |  2017*
*Photo by Bob Dennis*

▲ Susan Callahan
Silver Spring, Maryland, USA
susancallahanart.wordpress.com

*Stovetop*
*55 × 55 inches (140 × 140 cm)  |  2018*
*Kitchen Life  |  Photo by Eric Reiffenstein*

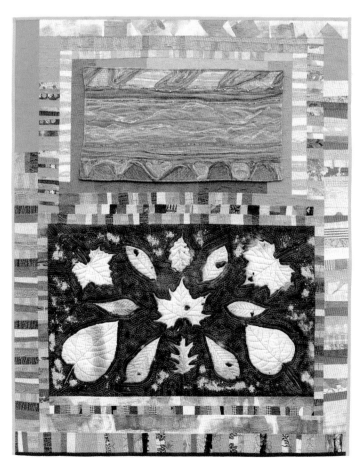

◀ Sue Reno
Columbia, Pennsylvania, USA
www.suereno.com

*In Dreams I Found Utopia*
*67 × 53 inches (170 × 135 cm)  |  2019*

▲ Jacque Lynn Davis
Freeburg, Illinois, USA
www.jacquedavis.com

*I Cannot Hear You Anymore*
*30 × 17 inches (76 × 43 cm)*  |  *2018*
*Private collection*  |  *Photo by Sarah Abbott*

▲ Ann Brauer
Shelburne Falls, Massachusetts, USA
www.annbrauer.com

*ocean sunrise*
*47 × 37 inches (119 × 94 cm)*  |  *2019*
*Photo by John Polak*

◀ Jayne Willoughby
Edmonton, Alberta, Canada
www.jaynewilloughby.ca

*Veil Series Study 51*
*64 × 44 inches (163 × 111 cm)*  |  *2017*

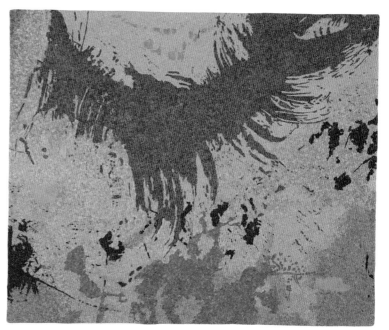

▲ Michele Hardy
Silverthorne, Colorado, USA
www.michelehardy.com

*Surfaces #11*
*32 × 32 inches (81 × 81 cm)  |  2017*

▲ Barbara Oliver Hartman
Flower Mound, Texas, USA
barbaraohartman@aol.com

*Aftermath*
*45 × 55 inches (114 × 140 cm)  |  2018*
*Photo by Sue Benner*

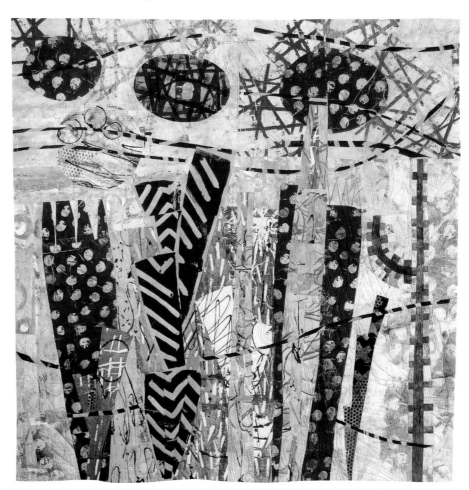

Pat Pauly ▶
Rochester, New York, USA
www.patpauly.com

*Sapphire Garden*
*77 × 77 inches (196 × 196 cm)  |  2019*

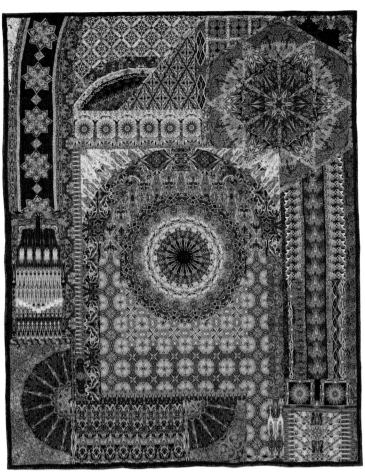

◄ Paula Nadelstern
Bronx, New York, USA
paulanadelstern.com

*Kaleidoscopic XLI: The Prague Spanish
Synagogue Ceiling*
*79 × 64 inches (201 × 163 cm)  |  2018*
*Photo by Jean Vong*

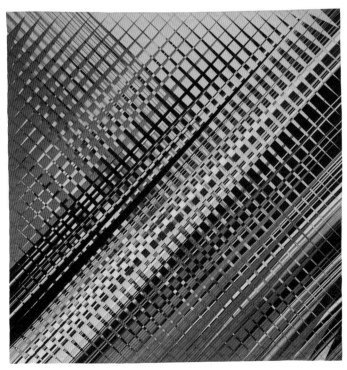

▲ Dan Olfe
Julian, California, USA
www.danolfe.com

*Color Square #5*
*59 × 58 inches (150 × 147 cm)  |  2019*

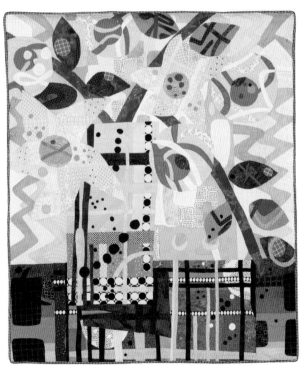

▲ Katie Pasquini Masopust
Fortuna, California, USA
www.katiepm.com

*Valerian*
*43 × 36 inches (109 × 91 cm)  |  2018*
*Photo by Photography Studio Caroline Wright*

▲ Daphne Taylor
Montville, Maine, USA

*Quilt Drawing #21*
*57 × 50 inches (145 × 126 cm)* | *2017*

▲ Gwyned Trefethen
Cohasset, Massachusetts, USA
www.gwynedtrefethen.com

*Cohasset Sunrise*
*82 × 59 inches (208 × 150 cm)* | *2019*
*Photo by Dana B. Eagles*

▲ Shea Wilkinson
Omaha, Nebraska, USA
www.sheawilkinson.com

*Reception*
*32 × 32 inches (81 × 81 cm)* | *2018*

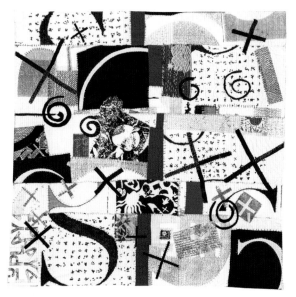

▲ Susie M. Monday
Pipe Creek, Texas, USA
www.susiemonday.com

*Outside the Lines*
*40 × 40 inches (102 × 102 cm)* | *2017*

# EBB AND FLOW

Many things in life and history demonstrate a recurring pattern of change, cycles of growth and decline. From movements in history to the phases of our lives, the seasons, the position of the stars and planets, conversations, even the progression of a piece of music or literature.

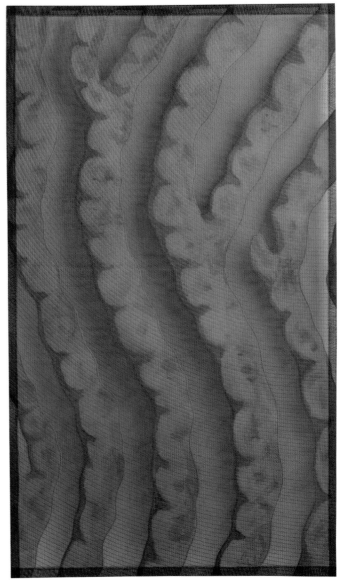

Dianne Firth
Canberra, ACT, Australia

*Seaweed*
42 × 36 inches | 2018
Photo by Andrew Sikorski

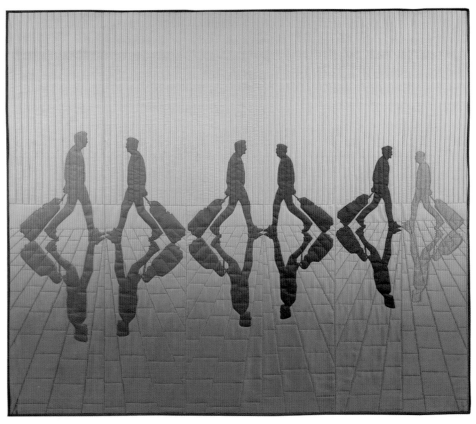

Cynthia Friedman
Merion Station, Pennsylvania, USA
http://www.cindyfriedman.com

*Journey in Solitude*
42.75 × 50.75 inches | 2019
Photo by John Woodin

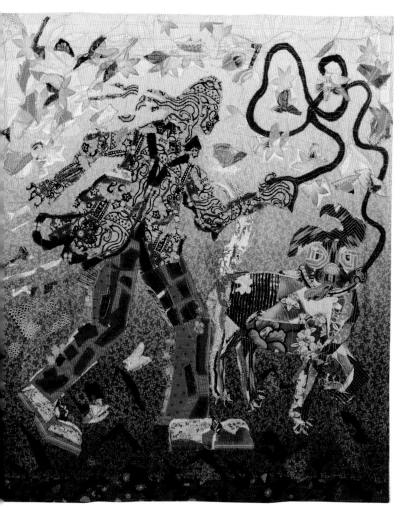

Jim Hay
Misato-machi, Takasaki, Gunma, Japan
www.jim-hay-artist.com

*Comes the Wind*
46 × 38 inches | 2020

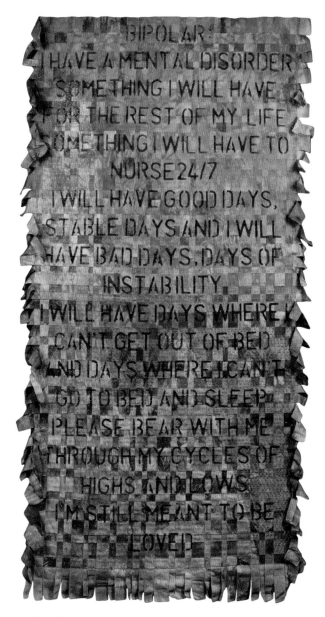

Marjolein van der Eijk
Dordrecht, Zuid-Holland, Netherlands

*Bipolar, a life with a fringed edge*
60 × 29.5 inches | 2019
Photo by Cleary Creative Photography

Fabia Delise
Trieste, Italy
https://fabiadelise.it

*Route 112 NH*
49 × 49 inches | 2020

# Index